ART AND HISTORY OF ATHENS

TEXT BY
IOLI VINGOPOULOU
AND
MELINA CASULLI

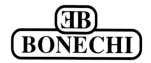

BONECHI

INDEX

ART AND HISTORY OF ATHENS
Publication created and designed by *Giampaolo Bonechi*
Photographic research by *Giovanna Magi*
Graphics and layout by *Serena de Leonardis*
Text by *Ioli Vingopoulou* and *Melina Casulli*
Research assistant: *Nasia Athanasiou*
Translation from Greek by *Traduco snc di Bovone e Bulkaen* (Florence)
Editing by *Simonetta Giorgi*

© Copyright 1998 by Casa Editrice Bonechi, - 50131 Firenze - Italia
All rights reserved. No part of this book may be reproduced without the written permission of the publisher.
Printed in Italy by Centro Stampa Editoriale Bonechi.

The cover and layout by the Casa Editrice Bonechi
graphic artists in this pubblication are protected by international copyright.

English translation by Julia Weiss *for Traduco snc di Bovone e Bulkaen (Florence).*

Reconstruction drawings by Stephen Sweet *(pages 8-9) and* Stefano Benini *(page 19).*
Map by Valentina Buti.

Photographs from the Archives of Casa Editrice Bonechi taken by Smara Ayacatsica ,
Gianni Dagli Orti *and* Luigi Di Giovine.
Photographs on pages 108 and 109: a courtesy of the Benaki Museum.
Photographs on pages 110 and 111: a courtesy of the National Gallery of Greece.
Pages 116 bottom and 117: photos by Hittalis.

ISBN 88-7009-795-1

* * *

HISTORY OF ATHENS

The history of Athens, capital of modern Greece, dates back at least five thousand years. The natural landscape, the sea and climate were determining factors in the make-up of its people, and contributed to the creation of an exceptional civilization that left its mark on the entire ancient world and laid the foundations for the modern one.

There is evidence that the Acropolis has been inhabited since the Neolithic Period. The visible remains of human activities merge with ancient myths that ascribe the founding of the city to Theseus around the middle of the XIII century B.C. Some traces of the fortifications dating from that period, along with some Mycenaean tombs reveal how Athens was organized in a city. The advent of the Dorians (1100 B.C.) who destroyed the Mycenaean civilization did not have any consequences for the city, and its inhabitants were proud of their ancient origins.

The Geometric Period, which came at the end of the Mycenaean era coincides with the development of an important trading and artistic center in Athens, and with the development of the Greek alphabet (around 750 B.C.) which is still used today. The famous Athenian Geometric vases are permeated with the spirit of the Homeric poems which are the basis of the Ancient Greek world.

The VI century B.C. was an important milestone for Athens. Solon, philosopher and lawmaker, laid the foundations for the organization of Athenian society, that was even respected by the tyrant Peisistratus. Later, Cleisthenes drew up the principles of Athenian democracy that made the city famous and unique throughout the Greek world. The VI century was also a time of astonishing growth in all the arts, due mainly to Peisistratus' efforts. It was he who rendered the feasts of Athena, Poseidon, Demeter, Artemis and Dionysus magnificent, awesome events.

At the beginning of the V century B.C. Athens suffered the effects of the Persian Wars (490-479 B.C.). The city was reduced to rubble, the walls torn down and the Acropolis buildings were burned. However, faith in democracy was strengthened by these events, and after the victories at Marathon, Salamis and Platea, a new city was built over the ruins left by the defeated Persians. Themistocles, Cimon and Pericles, enlightened leaders, ruled over what is now known as the Classical age of Athens. The new city was beautified with buildings that have been admired ever since they were constructed. Literature also contributed to this harmony: Socrates, an authentic son of the city prepared the groundwork for philosophic thought that is still valid today. The dramatic poets Aeschylus, Sophocles and Euripedes spread the teaching of the universal values of Democracy: civilization, equilibrium and spiritual harmony do not oppress man, but give him the treasures of wisdom and of knowing

how to live well. The first theater in the ancient world was built off to one side, below the Acropolis. It was an Attic invention which would become a fundamental element of urban organization in every other Mediterranean city. Participants in the poetry contests had to match each tragedy with a comedy where they had full freedom to make social criticism. The comedy, with its immediacy was able to make the free and democratic citizens of this young society think and reflect. It was a society that loved logic, reason, moral principles and responsibility for its own actions. Attic letters and the quest for knowledge gradually led to the transformation of ideas into facts. The harmony of mathematics was translated into the solidity of buildings such as the Parthenon, the Erechtheum and the Propylaea on the Acropolis. The mathematical rationality of the golden section was applied to architecture and sculpture by Ictinus, Callicrates and Mnesicles. Ancient myths, poetry, the Hellenic epos and the philosophical rule of moderation guided Phidias' hand in the incomparable sculptures of the Parthenon.

The Athens of Pericles was at the apex of its glory during the attempts to achieve political and cultural unity of the ancient Greek city states. It is an accepted fact that each flourishing moment bears the seeds of decline. Towards the end of the V century the Peloponnesian War, the result of an ideological conflict between Athens and Sparta, weakened Athens both politically and militarily. But even in this turbulent period, the philosophical spirit of Plato managed to shine: his works lit the path for the European Renaissance of the fifteenth and sixteenth centuries.

In the IV century the Macedonians, a new power from Northern Greece, were to play a decisive role in Greek events. The Athenians certainly tried to react, but in vain. After the Battle of Chaeronea (338 B.C.), Philip, King of Macedonia managed to unite the Greek cities for the first time in history, with the aim of making the Persians pay for everything they had done to the Greeks, and mainly the Athenians, during the wars. Philip himself was unable to achieve this goal which was fulfilled later by his son, Alexander the Great. Aristotle, his teacher and the most brilliant mind in the ancient world, that was to enlighten western thought from the Renaissance on, lived and taught in Attica for many years. After Alexander's victories in Asia, the new Hellenistic era was anything but a period of decline for Athens. The entire civilized world looked upon Athens as the home of the Muses, the spiritual treasure and cradle of humanity. Although Athens did not regain her political strength, she was the focus of the world's admiration and obtained the goodwill of the great figures of the Hellenistic period (323-146 B.C.) such as Demetrius Poliorcetes, the Ptolemies of Egypt and the Attalids of Pergamum. In the city, the philosophical academies

of Theofrastus, a pupil of Aristotle, the Stoà of Zeno and the Epicurean School flourished. In parallel, the fine arts flourished as well with fine sculptures by Praxiteles and Scopas.

Rome, the new world power and threat to the East was on the scene by the II century B.C. Notwithstanding their rather spasmodic reactions, in 86 B.C. the Athenians fell to Sulla who tore down the city's walls. However, even the Romans, lured by the city's past and her monuments, helped embellish Athens. Julius Caesar, and the emperors Augustus, Marcus Aurelius and mainly Hadrian showed their favor on several occasions.

Athens, philosophical center of the known world, did not remain untouched by Paul's preaching in 51 A.D. Barbarian raids in the third century A.D. marked the end of antiquity. In spite of the destruction wreaked by the Heruli, a Germanic people, in 267 A.D., Athens continued to be the home of philosophical academies that attracted students from all parts, including Basil the Great and Gregory Nazianzene, Fathers of the Greek Church. This was the city's last contribution to Greek learning: in 529 A.D. Justinian closed the academies.

In the following centuries Athens was merely a small provincial city in the Ottoman Empire, and its temples were transformed into Christian churches. Around the XI and XII centuries some prosperity returned, as shown by the construction of Byzantine churches which still stand today, and by the activities of scholars such as the Metropolitan Michael Coniatis who were aware of the city's classic past.

After the Byzantine Empire was dismembered by the Franks in the IV Crusade, Athens fell in 1204 and met the same fate as many other Greek cities. It was occupied for 250 years and was governed by Otho de la Roche, the Catalans and the Acciaiuoli of Florence. In 1456 the Sultan Mehmed II, the Conqueror, overthrew the Frankish dukes of Athens. At this crucial moment in her history, Athens gave the West one of her brilliant sons, Demetrius Chalkokondilis, a learned man who published the first edition (1488) of Homer's poems in Florence.

From 1456 to the mid-seventeenth century Athens remained isolated within the Ottoman Empire. It was Renaissance and humanist interest in ancient Greek literature that brought the Europeans to Athens. Travellers, diplomats and scientists crisscrossed the land, documenting monuments and seeking antiquities to enrich their collections. In 1687 Athens was under fire from the cannons of the Venetian Francesco Morosini, who irreparably destroyed the Parthenon.

From the mid-seventeenth century classical antiquity became the object of systematic scientific research and European admiration. The statuary on Athenian monuments was documented and studied, and gave rise to the neoclassical style in Europe. Athens' treasures attracted and inspired Lord Byron who visited the city several times in 1809 and 1810. However, this "cult of antiquity" was often disastrous for the monuments themselves, and sculptures were frequently carried off to feed European collections. Athenians participated actively in the Greek War of Independence in 1821. They protected their city's freedom for five years, but the Turkish guard delivered the Acropolis to the Greeks in 1833. In 1834 Athens, a city of 10,000, was declared capital of the new Greek nation, and the residence of Otto of Bavaria, King of Greece. A new era began. The first city plan prepared by a Greek, Kleànthis and a German, Schaubert, was worthy of Athens' past, but it was never put into effect. Reconstruction, however, could not be stopped. Private homes sprouted alongside of neoclassical public buildings, and whole new districts were created.

The history of Athens, capital of a small country, in the nineteenth and early twentieth centuries is closely linked to the history of all Hellenism. The liberation of Thessaly and then Epirus, followed by Macedonia, Thrace, the Ionion and Aegean islands, and then Crete, was difficult for the Greek people and had positive political repercussions for Athens. Greece took part in World War I, and the subsequent clash of interests in Europe led to the heartbreaking exodus of Hellenism from Asia Minor. In 1923 nearly one and a half million refugees flooded into Athens and Greece. The population boom and social upheaval created new conditions for the city's inhabitants. Athens and Greece itself then went through a democratic phase after the disaster of Asia Minor. but soon the democratic euphoria was quenched by Fascist oppression. Athens survived under unspeakable conditions during the German occupation (1940-44) and the civil war (1944-49). During the fifties, a time of great political intolerance Athens was gradually transformed into the focal point for the entire country's economic, industrial and cultural development. A new wave of domestic immigration occurred and increased the capital's already serious problems. After a new dictatorship (1967-74) and the abolition of the monarchy, democracy finally returned to Greece, its original birthplace.

Currently, with a population of 4,000,000, Athens is a large, cosmopolitan, European capital: a modern city fully aware of the strength of its enormous cultural and spiritual heritage.

The Acropolis seen from the hill of Philopappos.

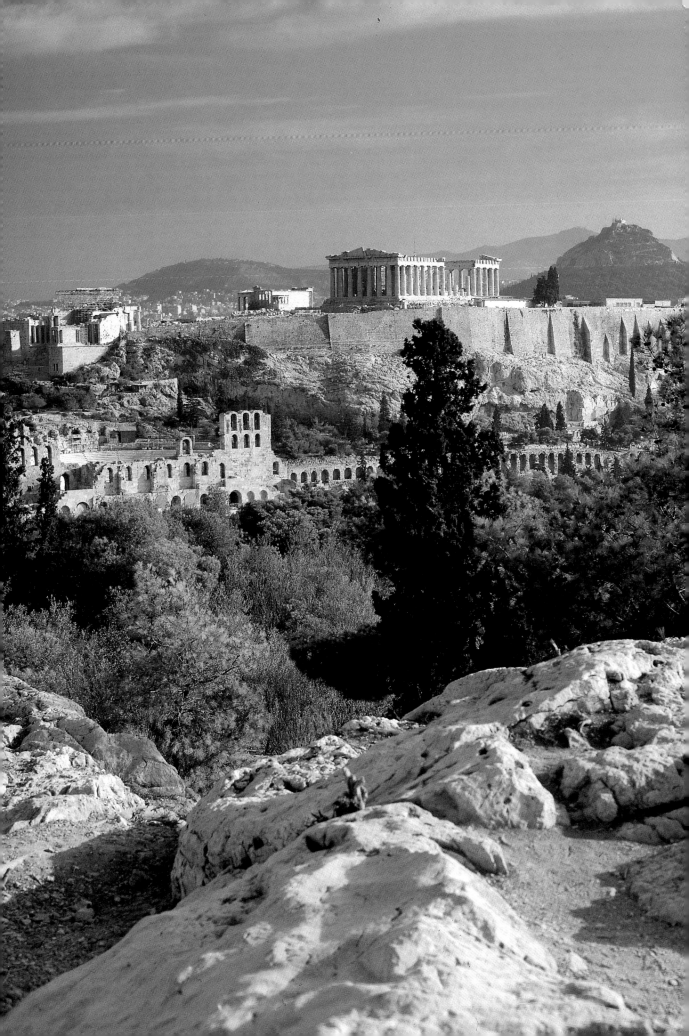

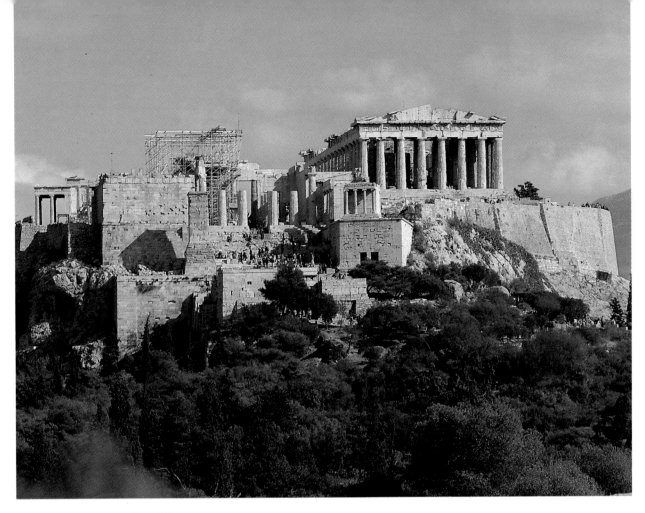

The Acropolis from the Pnyx hill.

THE ACROPOLIS

THE HISTORY OF THE ACROPOLIS

The Acropolis rises in the middle of the Plain of Athens: a natural semicircular fortress enclosed by mountains on three sides and opening to the sea on the south, bathed by the Attic sun. It is the universal symbol of the spirit of the art and values that were born, developed and raised to the highest levels by Greek civilization during the Classical Period. No other place in the world contains such a large number of priceless masterpieces in such a limited area.

The history of the Acropolis is the history of Athens itself. The imposing, 156 meter high cliff with its steep sides that can only be scaled from the south-west was first inhabited during the Neolithic period (3000 B.C.). Its configuration, that makes it a natural and safe refuge, its flat surface that favored settlement and the abundance of fresh water from the springs on the slopes were major factors that defined its role in history over the centuries.

Acropolis (*'Akra-polis*) literally means "the high part of the city". By the Mycenaean Era there were already massive cyclopean walls and a royal *mègaron* as could be found in Mycenae and Tiryns. The Acropolis became an unassailable fortress and a major point of reference; and this would remain its peculiar feature over the centuries in spite of political, social and religious changes. The Acropolis merely adapted to changing circumstances.

At the end of the Mycenaean Period and with the abolition of the kingdom, the *mègaron* was replaced by a first temple dedicated to the two divinities who protected the city: Poseidon god of the sea, and Athena, goddess of the olive tree. This marked the beginning of the Acropolis' new role as a place of worship, while the new rulers transferred the seat of government, as it were, to the center of the city in the valley. The mythical heroes and prehistoric kings, Cecrops and Erechtheus would later be worshipped with the gods in a sort of link between the

6

Mycaenean past and the Archaic present. During the VI century B.C., on the wave of Peisistratus' innovations, two new temples were built to replace the older one. At the same time, worship on the cliff began to take on more definite outlines. The magnanimous and polymorphous Athena, the wise goddess who could protect the city like Polias and its people in their manual and intellectual pursuits, like Ergane, became the fully armed warrior Pallas, leader in battle, and Nike their guide to victory. Veneration of the goddess became inextricably linked to the fate of the city. The Athenians portrayed her using natural symbols of fertility and wisdom, the olive tree, the snake and the owl. During the Age of Pericles she was given the names of *Parthènos* (Virgin) and *Promachos* (She Who Fights in the Foremost Ranks) when her weapons were moral and her inspirational values celestial.

During the Persian Wars (490-479 B.C.) the Archaic *hekatompedon temple* of Athena (100 feet long) was still unfinished. After the victorious Athenians returned from the battle of Salamis in 480 B.C. they found their city destroyed and the Acropolis burnt. They immediately set to work rebuilding, with the memory of recent heroic battles and the effects of the unheard of sacrilege still fresh in their minds. It was during the Age of Pericles (V century B.C.) that Athens reached the peak of its economic and cultural power. The citizens, aware of their superiority, confident, and proud of their achievements and courageous for having built the world to their measure, wanted to thank the gods for their benevolence, impress the rest of the world and release the creative spirit of their city through all the available modes of expression and with immortal works. Pericles launched a grandiose building plan, unequalled in the Greek world, to give Athens the aura befitting its political power. He entrusted the work to brilliant artists such as Phidias, Ictinus, Callicrates and Mnesicles, and even to all the people of Athens who gave life to the monuments on the Acropolis and to the magnificent Parthenon, a temple and hymn to Athena. This fervor was damped by the Peloponnesian War (431-404 B.C.) which after a brief pause (Peace of Nycea, 421-415 B.C.) ended with the defeat of Athens at the end of the V century B.C., but most of the building had been completed.

During the Roman period, the Acropolis maintained the appearance of its prime period, as well as the votive gifts. Only a small circular temple, dedicated to Roma and Augustus, was added in 27 B.C. It was the spread of Christianity and the prohibition of pagan worship that stripped the Acropolis of its artistic treasures. Many of the ancient votive statues were lost either on the road to Constantinople or in the name of the new religious sect, while the temples and monuments were transformed into Christian churches. When the Franks occupied Athens in 1205 they transformed the Byzantine Parthenon of Our Lady of Athens into a Catholic cathedral and the Propylaea into a palace for the Latin prince. The Acropolis changed hands from the Frankish, De la Roche dukes, to the Catalans and finally the Acciaiuolis, a Florentine merchant family. After a two-year long siege it was surrendered to the Turks, and it was under their domination that it suffered the greatest damages. The Parthenon was transformed into a mosque, and the Erechtheum into a harem for the Pasha of Athens. The destruction of the Propylaea in 1656 and the bombing of the Parthenon in 1687 by Francesco Morosini marked the start of the disfigurement and sack of the monuments. However, the most consistent and systematic removal of art treasures from the Acropolis was done by Lord Elgin, English ambassador to Constantinople. In just a few years starting in 1801 his commissionaires literally stripped the Parthenon of all the sculptures that had survived previous attacks and bombardments, like the Erechtheum and a Caryatid, and other architectural components. Everything was taken to London where they comprise one of the most important collections in the British Museum. The first systematic archeological excavations of the site lasted from 1885-1933.

Treasures from the Archaic and Classical Periods were brought to light and the first steps to conserve and restore the monuments were undertaken. The work continued over the years, and in 1975 an important conservation and restoration project was undertaken by the Government Archeological Service in order to remedy the damage caused by rain, frost, earthquakes and air pollution. This sacred citadel, with the greatest creations of the most important moment of the Athenian Republic, source of inspiration for artists of antiquity and today, is 5,000 years old.

Today, the appearance of the Acropolis is quite different from what it was like in the Classical Period with its temples, votive offerings and overall arrangement. At that time, the sacred citadel had many more monuments than it does today. The rocky surface was covered with beaten earth, and arranged on several levels. Each monument was surrounded by its sacred open space and decorated by countless marble and bronze statues, paintings, embroideries, weapons, pottery, war booty, silver and gold masterpieces, all votive offerings to the deities. Most of the sacred feasts and rites were celebrated outdoors, around the temples and altars. This is why ancient temples were more richly decorated on the outside, with statues and frescoes rather than inside. The walls that surrounded the upper part of the Acropolis were much higher than today. They were built to protect—both physically and mentally—the temples and monuments, their precious cultural and spiritual values and the intense religious feeling they inspired.

RECONSTRUCTION OF THE ACROPOLIS (II CENTURY A.D.).

1. Propylaea and part of the processional route followed during the Panathenaean Festivals, leading to the Acropolis.

2. Temple of Athena Nike (wingless Victory).

3. Eleusis marble pedestal which, from 27 B.C. probably supported a bronze sculpture of Marcus Agrippa son-in-law to the Emperor Augustus, driving a chariot.

4. Sanctuary of Artemis Brauronia, protectress of women in labor and new mothers (VI cent. B.C.).

5. Gallery of Plaster Casts: a complex dating from V-IV century B.C. that contained primarily bronze votive offerings.

6. Majestic statue of Athena Promachos, probably built after the Athenians triumphed over the Persians at the Battle of Eurymedon in Asia Minor in 465 B.C. This was one of Phidias' early sculptures. Under the Byzantine Emperor Justinian (VI Century A.D.) the statue was taken to Constantinople where it was destroyed in 1203 on the eve of the city's fall to the Franks during the Fourth Crusade.

7. House of the Arrephoria, where four noble maidens, from 7 to 11 years of age, elected by the Athenians every year, wove the peplos for Athena Polias. They also participated in a mystic ceremony known as the Arrephoria, dedicated to fertility and sowing.

8. Parthenon.

9. Erechtheum.

10. Temple of Roma and Augustus, an elegant round building erected during the Roman occupations.

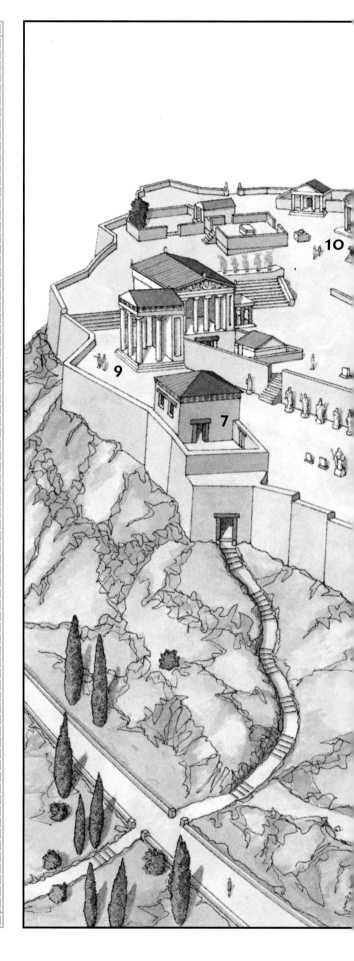

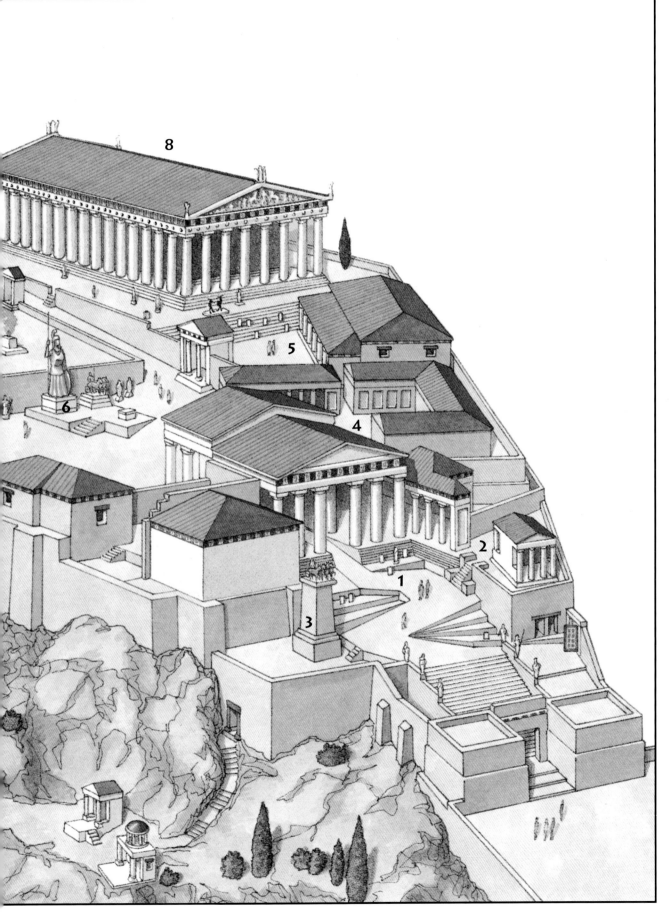

9

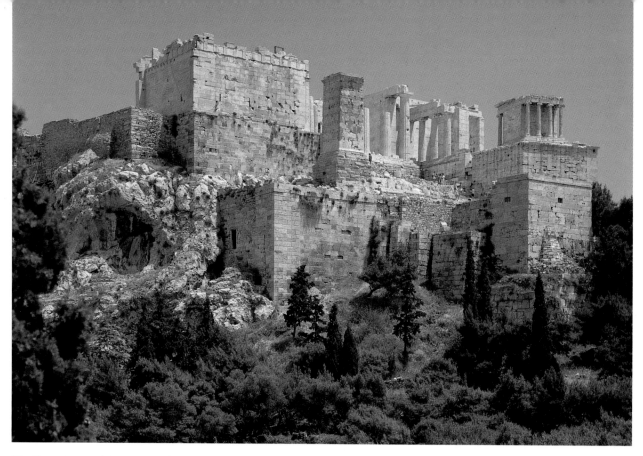

The Propylaea and the temple of Athena Nike from the Aeropagus.

Going up to the Propylaea, with the pedestal of the statue of Agrippa and the Pinakotheke.

THE PROPYLAEA

In ancient architecture, monumental doors were deliberately created to prepare the visitor's spirit for what would happen once inside. The door was the connecting link, the passage from the outside world and daily life to the inner, sacred world, the pilgrim's goal.

On the left side of the Acropolis, the **Propylaea** have long represented the finest example of this type of architecture.
During the Mycenaean Period, a narrow path led from the south side of the cliff to the fortified entrance to the Acropolis. When the city's political center was moved to the Agorà, and in order to facilitate "traffic" during the great Panathenaean festivals in 566 B.C., it became necessary to build another access which, however, was destroyed by the Persians. The Propylaea were built by Mneiscles, as part of Pericles' reconstruction program, between 437 and 432 B.C., when work was interrupted because of the Peloponnesian war.
During the following centuries, the Propylaea suffered many blows: part was transformed into a Christian church, and another into a residence for the Frankish princes.
In 1656 during the Turkish occupation lightning

struck a portion that was being used as a powder magazine. The roofs, frontons and the ceilings decorated with gilded stars were blown to smithereens. The Propylaea, made of Pentelic marble have six superb Doric columns on the façade of the central building, and six Ionic columns on the sides of the main entrance. Five symmetrically arranged doors—the center one being the largest—connect the east and west parts.
The wings to the left and right of the entrance, respectively are gracefully harmonious even though they are not symmetrical. Three small Doric columns form a stoà towards the temple of Athena Niké, while, on the other side, the large room of the Pinakotheke, with its painted panels, gave the faithful a place to rest and meditate.

Currently the metal scaffolding that has been put up for restoration work does not hide the beauty of this building which is artistically comparable to the Parthenon and Erechtheum. It fits into the natural setting and was cleverly designed to fulfill its functions and offer the visitor an ideal glimpse of what is to come. The Parthenon, grandiose and impressive looms ahead in its full splendor, and in a perspective created to harmonize with the Propylaea behind us.

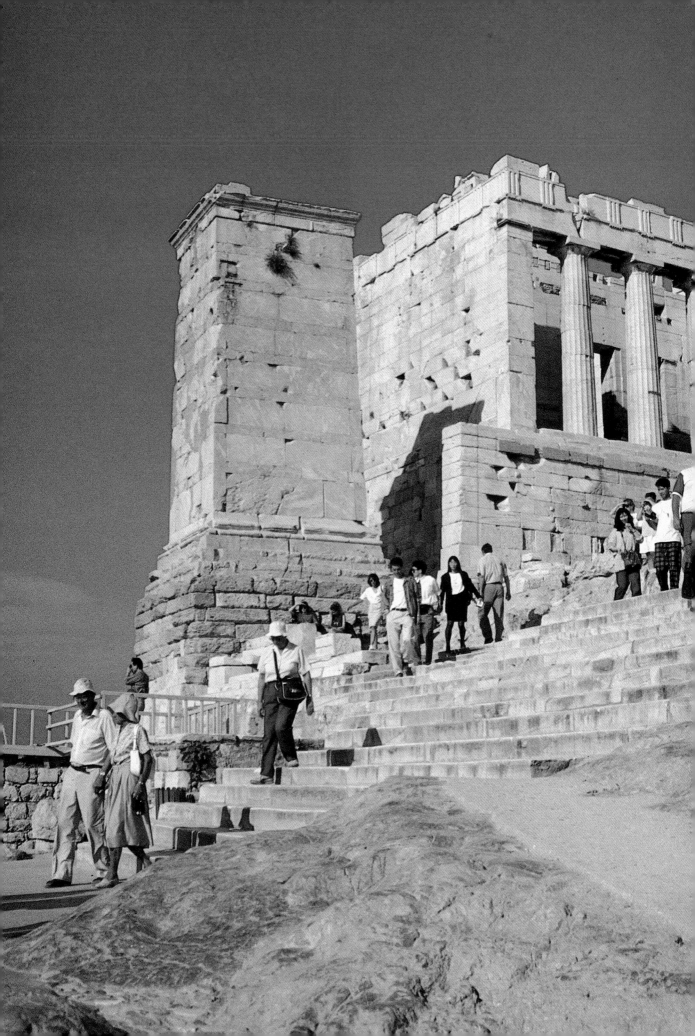

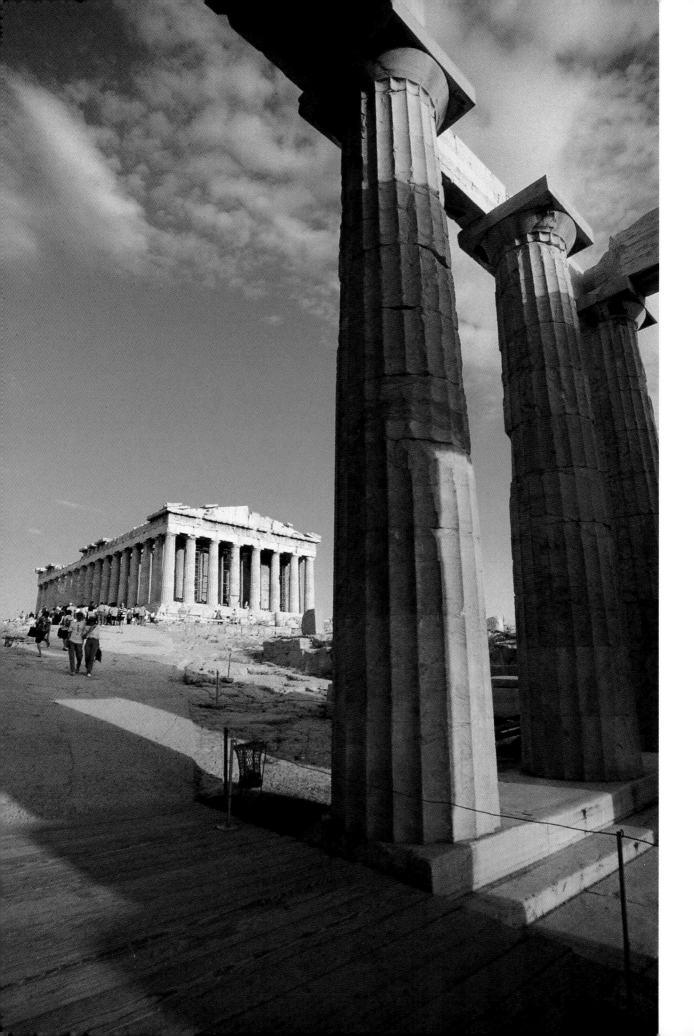

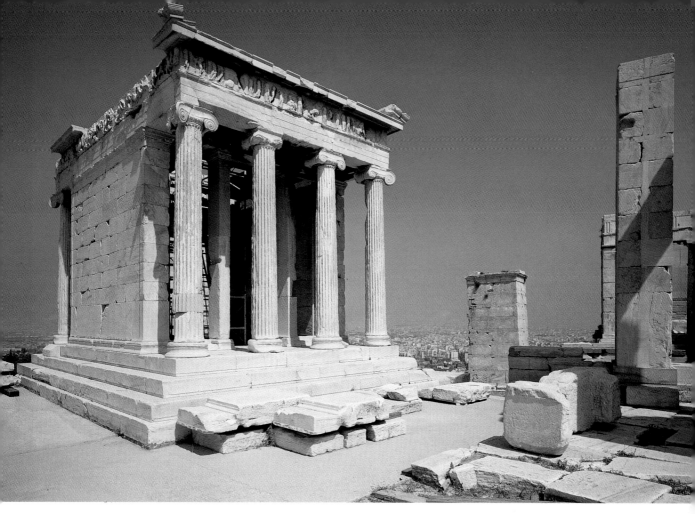

The Parthenon seen from the Propylaea. *The Ionic temple of Athena Nike.*

THE TEMPLE OF ATHENA NIKE

On a small plateau on the southwest side of the Propylaea stands the elegant and graceful **temple of Athena Nike**. During the Mycenaean period the fortifications this part of the cliff formed a sturdy tower from where the Athenians often repelled their enemies, and then placed their victory trophies.

The Greeks worshipped a special goddess, Nike, who had large wings and flew from one place to another. Here, however, it was Athena who was worshipped as the goddess of victory. The wooden statue portrayed her with a pomegranate in her right hand and a helmet in her left, expressing her peaceful and warlike attributes at the same time. Later writings tell us that the statue was "without wings" so that she would not fly away, but stay with the Athenians forever.
The white Pentelic marble temple was built by Callicrates, the architect who designed the Parthenon. It was built after Pericles' death between 427 and 424 B.C., on a spot that had previously been used for worship. In 1687 the Turks destroyed the temple of Nike and used the marble to reinforce the bastion of the Propylaea. In 1835, after the

architectural parts had been discovered and identified, the temple was rebuilt in its original position. Shortly before World War II it was restored with much more attention to its original appearance. The small, Ionic, amphiprostyle temple with four, tall, slim (4.06 meters) columns on the narrow sides is decorated with a frieze, relief carvings that run along the entire building. Only the portion on the eastern side, showing the gods of Olympus is original. The other sculptures, portraying the Greeks' battles against barbarians and other Greeks are in the British Museum (the ones on the temple are copies). Around 410 B.C. the temple terrace was decorated with a marble balustrade (on display in the Acropolis Museum), that ran the entire length of the bastion, depicting winged victories and slim figure of the goddess Athena.

This graceful Ionic temple, with its delicate sculptures stands alongside of the Doric majesty of the Propylaea, on the spot from where, according to myth Aegeus flung himself into the sea (now known as the Aegean) when he saw his son Theseus' ship returning from Crete with a black sail.

13

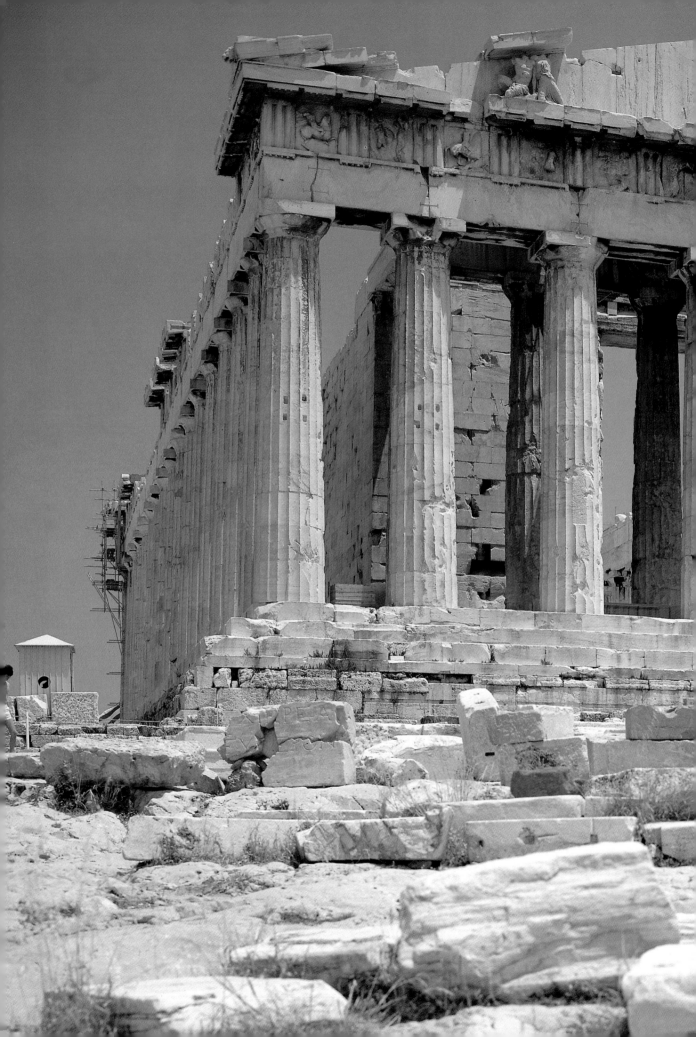

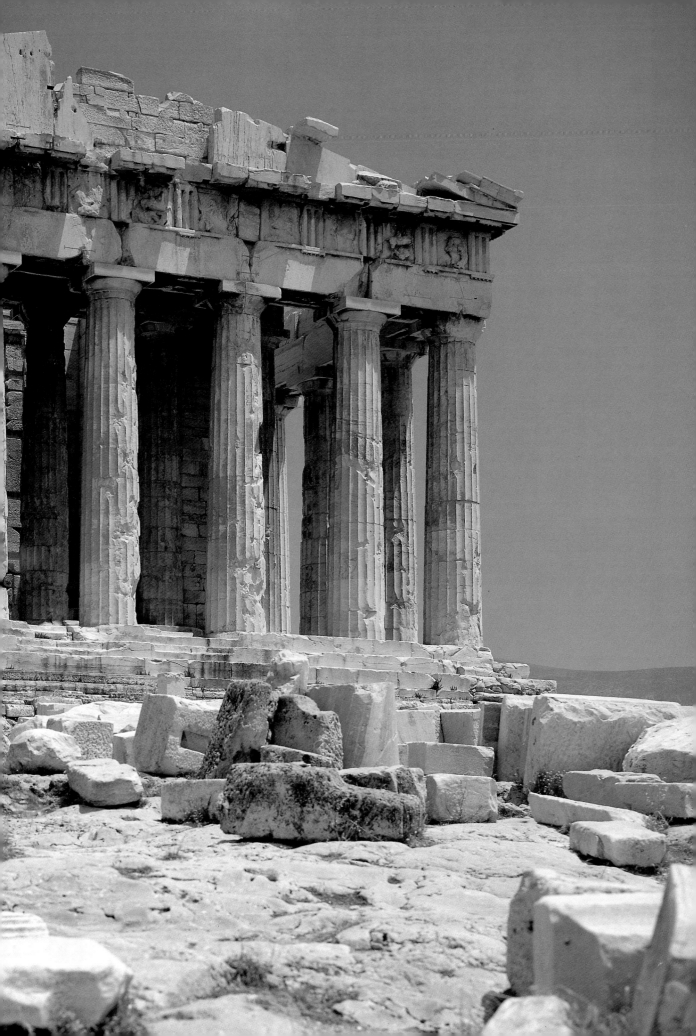

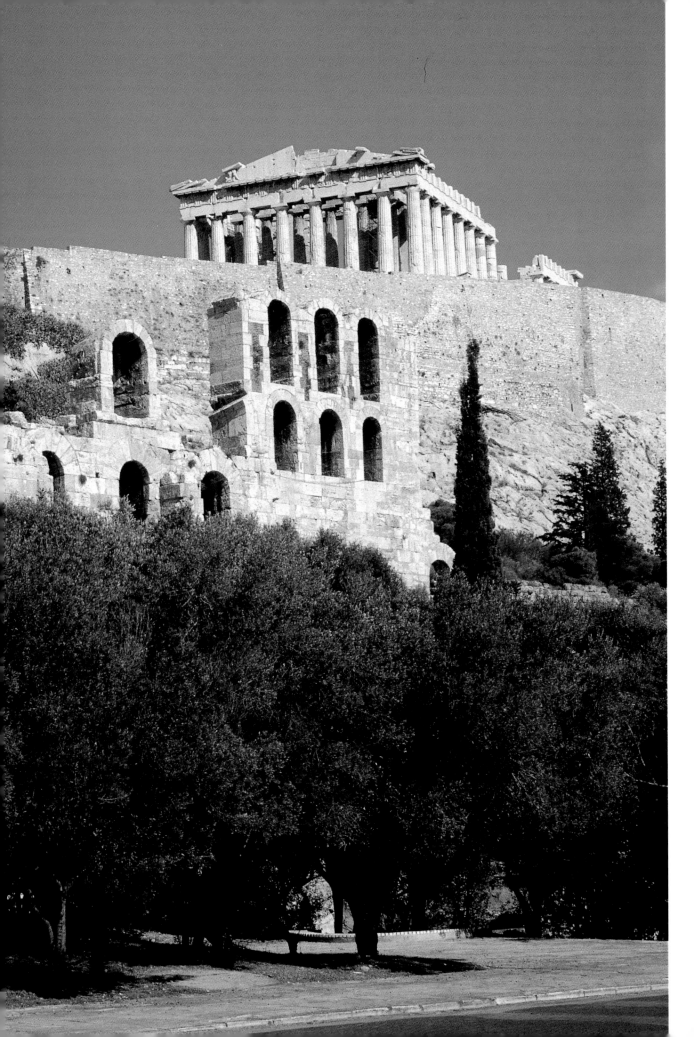

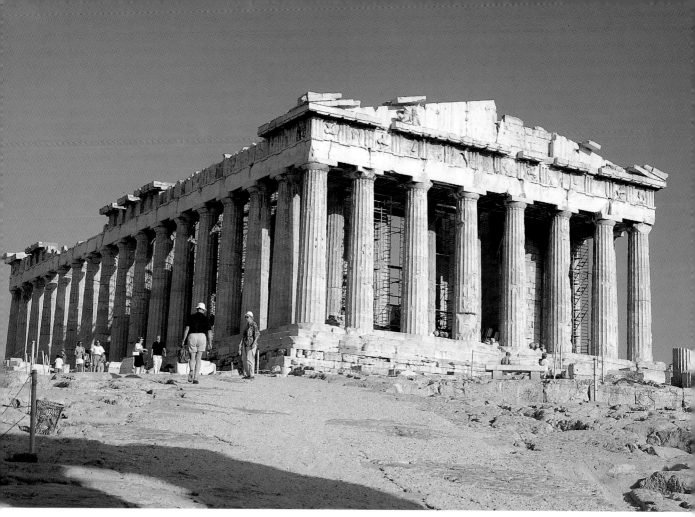

On pages 14 and 15: the Parthenon.

The Parthenon in all its glory.

Another view of the Parthenon.

THE PARTHENON

The Parthenon, "temple of Parthenos" is the symbol of the creative and artistic power that distinguished Athens in the V century B.C.. It is an immortal work of the mature years of the Classical period.

Construction was begun in 447 B.C., and it was delivered to the faithful nine years later while the sculptures were completed in 432 B.C.. The time it took to complete the building is inversely proportional to its poetic depth which is irrevocably linked to the extraordinary personality of Pericles and the genius Phidias whom his contemporaries already honored as the greatest figurative artist of the V century. The temple was built over the ruins of an Archaic Parthenon made of poros that had been destroyed by the Persians. The original building faced in the same direction, running from east to west and was the same length, though not as wide. Pericles' Parthenon was built entirely of Pentelic marble. It is a Doric peripteral temple, 69.5 meters

long, 30.86 meters wide and 13.72 meters tall, measured to the top of the tympanums. The columns are 10.43 meters tall: there are eight and seventeen on the short and long sides, respectively. With the exception of the tufo foundations and the wooden beams of the cella, the entire temple, including the roofing tiles was made of marble. The Parthenon is the largest Doric temple built in antiquity and is certainly the only Greek temple presenting such a brilliant and harmonious combination of Doric and Ionic elements as to make it a perfect model of the Classical temple.

The Parthenon's entire architectural plan obeys the basic mathematic proportion of 4:9 known as the "golden section". The architects succeeded in achieving the desired linear appearance by curving the straight lines and correcting the optical illusion created by the intense Attic sunlight. The system of curvatures and inclinations coupled with its plastici-

17

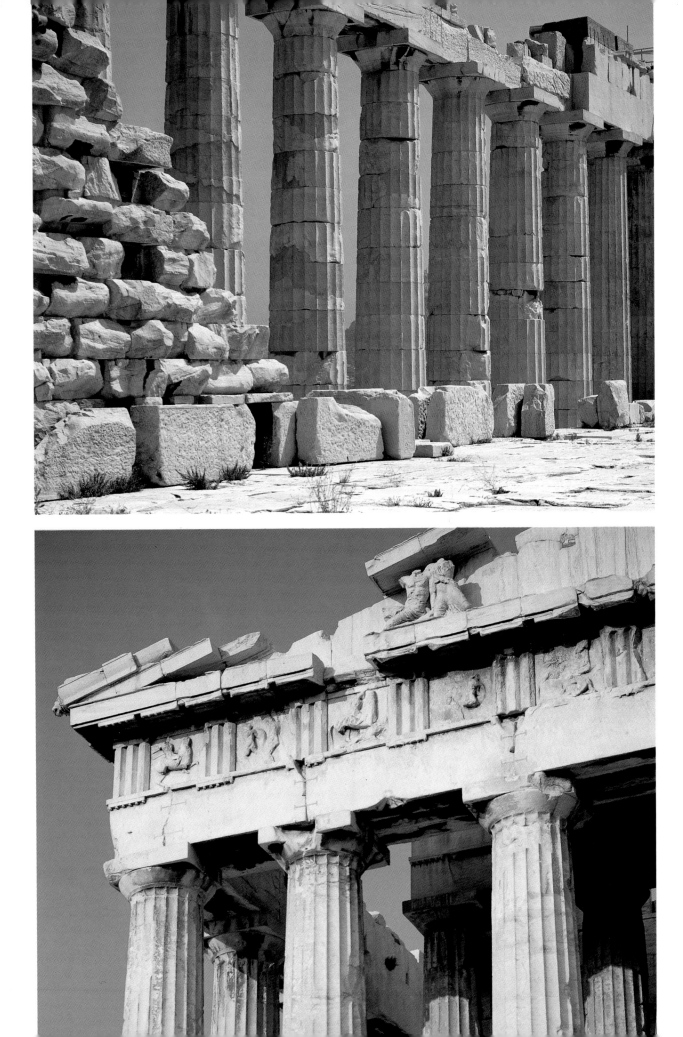

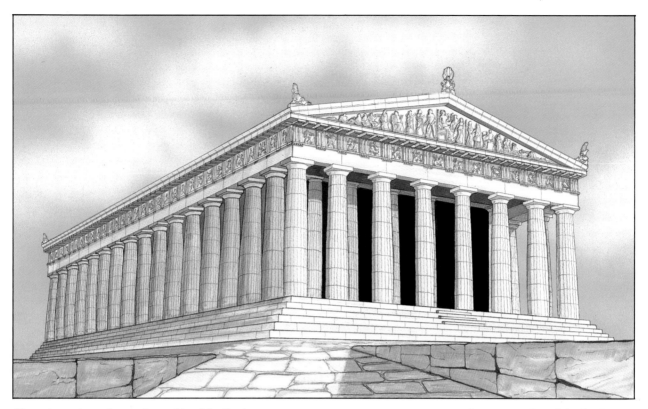

The colonnade on the northern side of the Parthenon seen from the cella. Below: the northwest corner of the Parthenon; detail of the tympanum and the metopes.

A reconstruction of the Parthenon.

ty give life to the entire structure. All the lines and horizontal surfaces are curved so that half the long sides is 11 cm above the horizontal plane, while half the short sides is 6 cm higher. The vertical lines and surfaces, that is the columns and walls are tilted inwards 7 cm. Furthermore, the columns are slightly tapered (approximately two fifths over their height). The twenty grooves add a sensation of lightness through the play of light and shadow and facilitate the eye as it moves along the structure and the natural transpositions towards the epistelium. In this sense each marble component was created separately and destined for a specific location. For the first time Greek architecture created a temple that was a live and vibrant whole.

Phidias, who superintended all the work and cooperated closely with Ictinus and Callicrates made the temple wider than originally planned in order to create a suitable home for the chryselephantine statue of the goddess, votive offerings and the city's treasure. The Parthenon was divided into three parts, the pronaos, the temple proper or cella and the opisthodomos. On the two façades there was a second row of six columns.

The eastern door led to the cella where a double, U-shaped colonnade encircled the votive statue of the goddess and supported the roof. The statue of Athena Parthenos by Phidias stood 12 meters tall and was hollow. It had a wooden frame, ivory was used to render the exposed parts of the body (face, hands, etc.) and gold plate (weighing 1140 kg) comprised the goddess's peplos. Gentle, proud and powerful, the goddess stood in the Parthenon for about 1000 years. In the V century A.D. the statue was

lost when it was moved to Constantinople. The opisthodomos, where the city's treasure was kept, was only accessible from the west.

The monument's architectural grace was further enhanced by the sculptures. The 92 metopes depicted mythological scenes inspired by the victories of the gods, of the Athenians and the Hellenes, the battles against the Giants, the Centaurs, the Amazons and the Trojan War. The zoophorous Ionic frieze in which Phidias immortalized the city's most solemn religious rite, the Panathenaic Festival, ran around the upper part of the temple.

The carved story of the Panathenaic procession began at the southwest corner of the temple and scenes developed rhythmically along the sides of the temple to meet again in the middle of the eastern side with the portrayal of the goddess receiving the peplos from the people. The two impressive compositions that decorated the frontons are great artistic achievements. The one on the east portrayed the birth of Athena as she sprang from the head of Zeus in full armor, while those on the right showed the competition between Athena and Poseidon for dominion over the city of Athens. The 52 carved figures were undoubtedly the fruit of Phidias' genius and the skill of his pupils Alcamenes and Agoracritos. A considerable number of these carvings are now in the British Museum.

Notwithstanding the changes and losses suffered through the centuries, the Parthenon still fascinates and exerts a powerful effect. It has maintained its musicality, artistic eloquence and esthetic harmony. It is a sublime embodiment of the classical Greek spirit and its ideals.

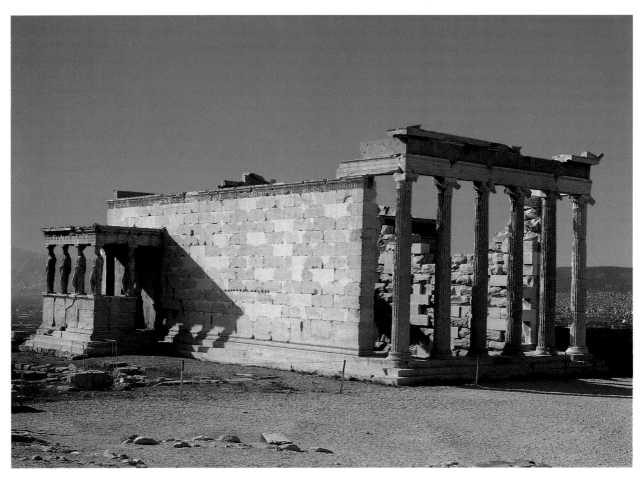

The Erechtheum seen from the east.

The Erechtheum seen from the southeast.

The portico of the Caryatids.

THE ERECHTHEUM

The **Erechtheum** stands on the northern part of the Acropolis where Athena and Poseidon competed for dominion of the city. Work on the Penteleic marble temple was begun in 421 B.C., but it was interrupted because of the war against Sparta and was only completed in 409-405 B.C. The building was transformed into a Christian church, a palace (during the Frankish occupation) and into a harem (during the Turkish occupation). All these changes had a severe impact on the interior. Restoration work at the beginning of this century, and in recent years has revived much of its original splendor.

The Erechtheum, a temple dedicated to Athena and Poseidon, who was identified with Erechtheus, a legendary king and divinity of Athens, had to be adapted to the irregularities of the site and comprise all the sacred symbols, tombs of mythical heroes and places for the conduct of ancient rites. The solutions are both complex and admirable. The building fits finely into the natural setting of the cliff and embraces the mythological places of worship in pure Ionic style. The eastern portion consists of a small prostyle temple with six elegant Ionic columns. The northernmost of these columns was taken to the British Museum and was replaced by a copy during recent restorations. This part of the temple was dedicated to Athena Polias and housed an ancient olivewood statue of the goddess which was dressed with a peplos every four years during the Panathenaic festivals. The Ionic door on the north, with its superb sculptures led into the sanctuary dedicated to the worship of Poseidon, Erechtheus and Hephaestus. This was where the "sea of Erechtheus" was located: a salt water spring that began to gush after being struck by Poseidon's trident. Near the western wall with its four Ionic columns grew the famous sacred olive tree that Athena, protectress of Athens gave to the city. Now, in its place there grows a small, young olive tree.

The **southern portico of the Korai or Caryatids** marked the grave of the mythical king Cecrops. Six graceful maidens, attired in Doric peplos, proudly

20

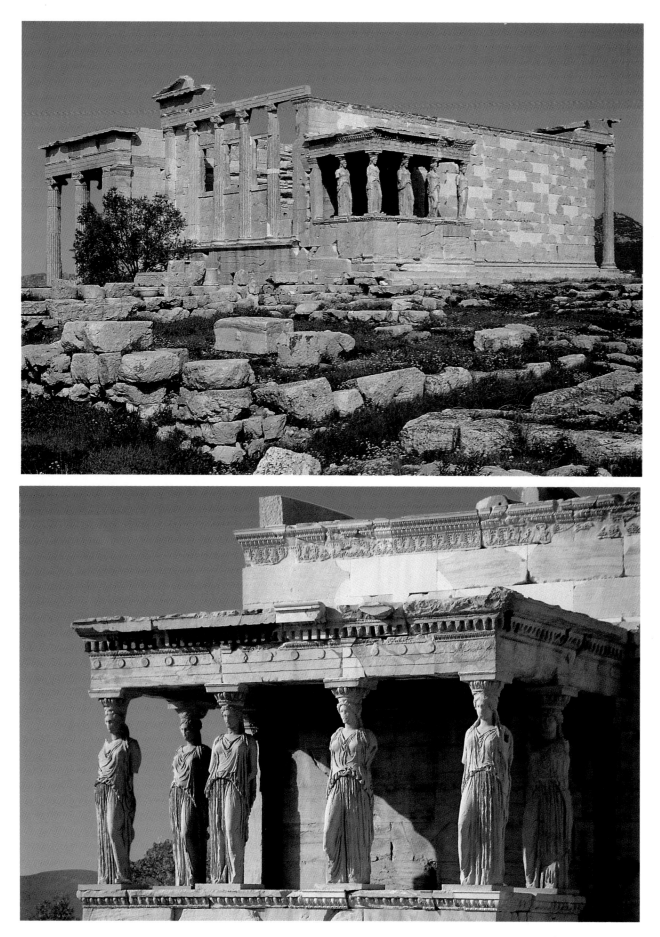

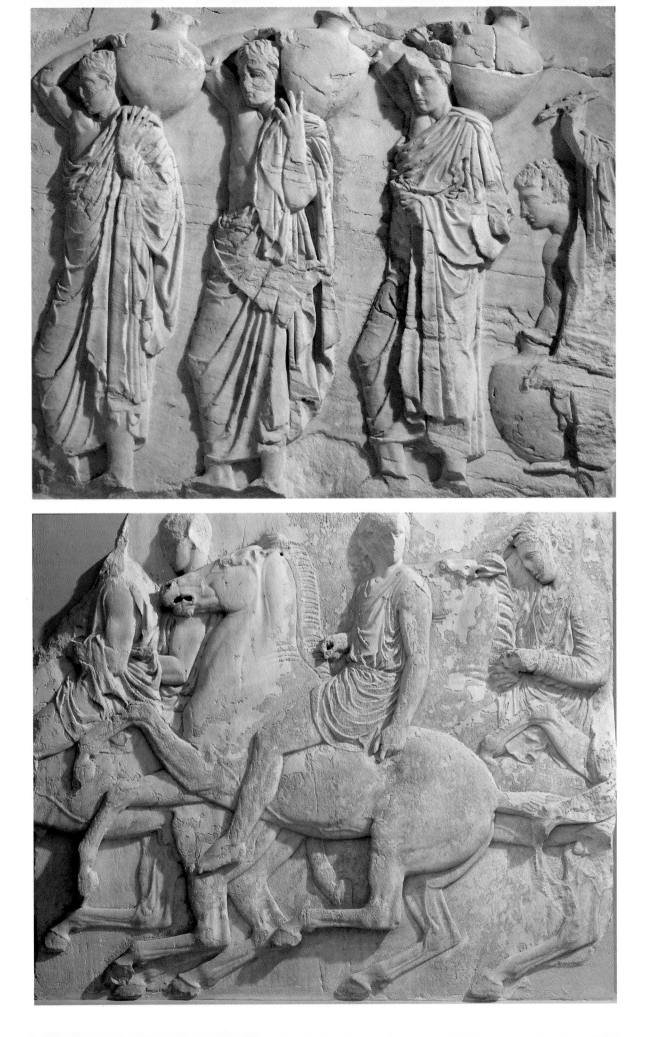

support the entablature over capitals with special decoration.Even if they differ as to details, they comprise a rhythmic whole, and have been attributed to some pupils of Phidias. The original Caryatids (in addition to the one in the British Museum) can be admired in the Acropolis Museum, since copies have been put in the original place. Carrying out their functional and spiritual duty, the Korai look up towards the Attic sky, an eternal symbol of artistic perfection.

The Erechtheum is the most complex and perfect structure of classical antiquity, with its elegant rich decorations and perfect details. It is an excellent counterbalance to the Doric power of the Parthenon, in the elegant and airy aura of the "rich style" that marked Attic art towards the end of the V century B.C.

THE ACROPOLIS MUSEUM

The Acropolis Museum contains artifacts that were discovered during excavations and restoration work on the citadel since the mid-nineteenth century. They are architectural portions of small poros stone buildings that adorned the Acropolis and were demolished by the Persians in 480 B.C., as well as votive offerings from the early Archaic period (sphinxes on columns, relief sculptures of chariots drawn by four horses, Rampin's horsemen and female statues). These works are representative of the level of Attic sculpture in the VI century B.C. One of the most outstanding examples is the marble **Calf-bearer** (570 B.C.); a farmer, per-

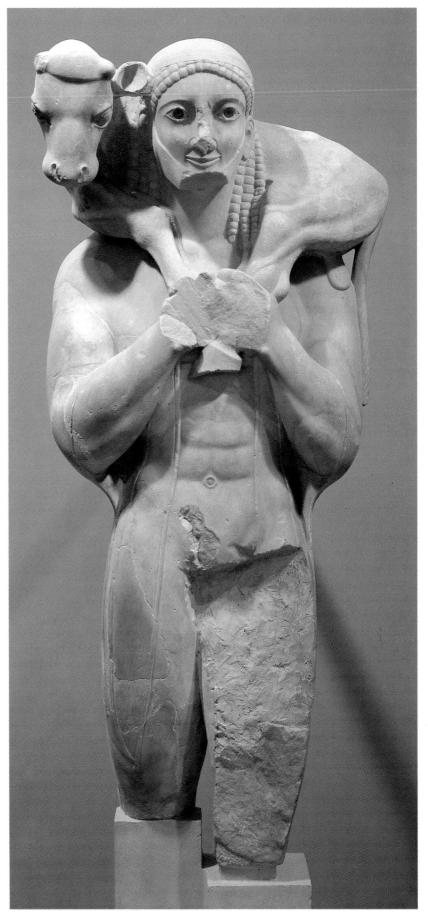

Sections of the Parthenon frieze in the Acropolis Museum, the waterbearers and the horsemen.

The calf-bearer.

23

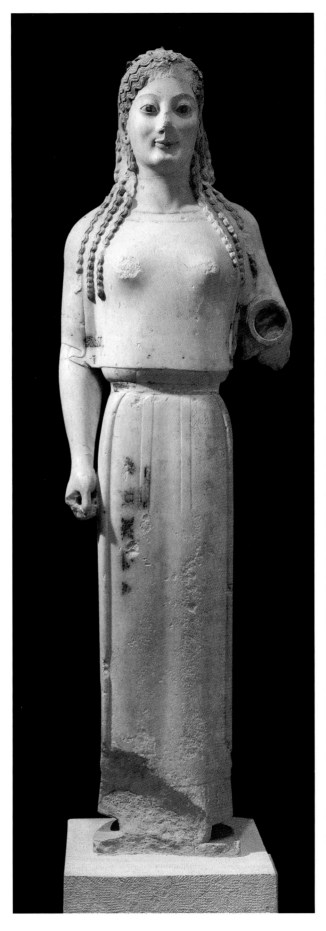
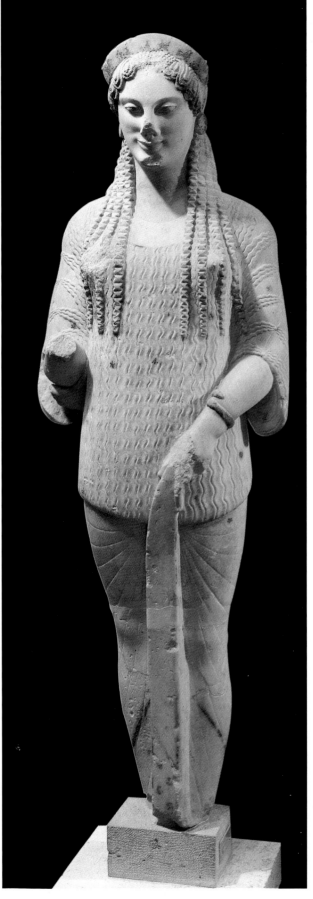

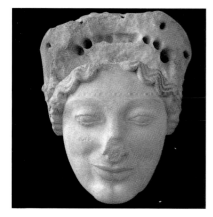

Archaic head of a kore (643).

Kore with the peplos.

Kore (670).

Kore (674).

Kore (682).

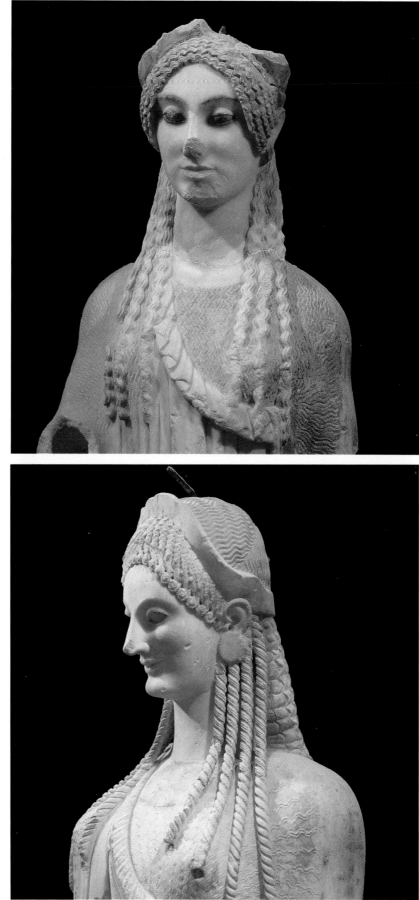

haps, named Rhombus, offering a calf to the goddess Athena. The young man's hands intertwine with the sacrificial calf's hoofs, and the way the two heads bend towards each other reveals the relationship between the youth and the calf at the sacred moment of the offering. The entire statue is richly colored and the youth's eyes, with his goodnatured smile are applied. The balanced distribution of volume which is obvious notwithstanding the frontal position of the group, contributes to making this one of the masterpieces of Athenian art. A series of marble female statues, the **Korai**, all dedicated to the goddess Athena are the most delicate and sublime expression of Archaic art. These were statues (*agalmata*) created to bring joy (*agaliasis*) to the goddess of the citadel. They wore elaborate Ionic chitons and himations, their curly locks were adorned with jewels and garlands; they smiled subtle smiles with thin Archaic lips as they held out their offerings to the virgin goddess. The **Kore with the peplos** (circa 530 B.C.) is an amazing statue of a

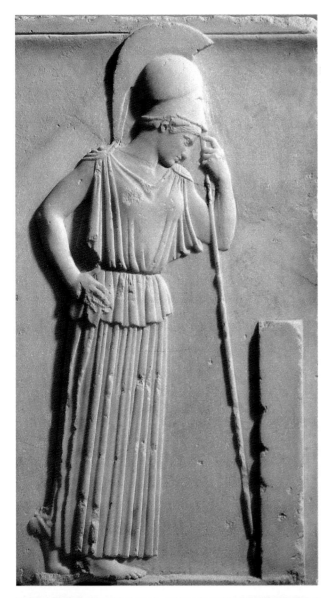

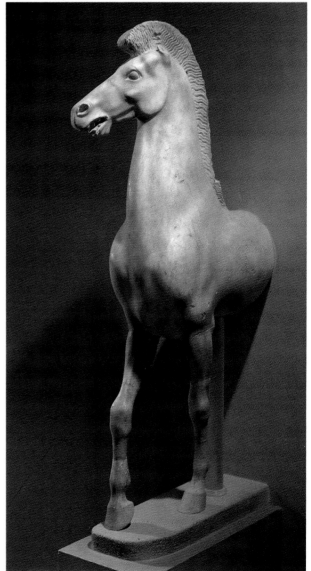

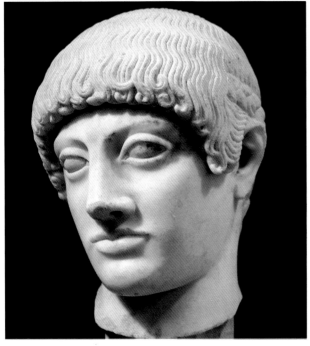

Relief sculpture of Thoughtful Athena.

Front of a horse.

The blonde ephebus.

Ephebus of Kritios.

kore wearing a simple Doric peplos over a light chiton. The solid impression created by the body is completed by the delightfully young head of the girl with the intense gaze, amiable smile and wavy hair. The sweet and, at the same time, monumental expressiveness of this statue also comes from the lively facial colors that have survived. The **Kore n.670** (circa 510 B.C) wears only a chiton that she holds high with her left hand, and is illuminated by unequalled youthful grace. The **Archaic head of a kore, n.643** (circa 510 B.C.) is the apex of Archaic art. The transparent skin embraces a thoughtful and peaceful smile. Even **Kore n.682** (circa 520 B.C.) is distinguished by its elaborate elegance, grandeur and pride, while the **Kore with the slanted eyes, n.674** (circa 500 B.C.) embraces all the graceful charm of Athenian beauty. Reserved, enigmatic and

thoughtful, it inspired admiration and respect, while exerting an irresistible inner charm.

The statues on the frontons that introduce the visitor to the early V century B.C. works, depicting the battle between the Gods and the Giants are dated around 525 B.C. The political, spiritual and artistic maturity of the Athenians was expressed through the "severe style" distinguished by new positions and expressions in the statues. The lyric smile and frontal poses were replaced by freer body movement and a more intimate, realistic facial expression. The head known as the **blonde ephebus** (480 B.C.) still had its original blonde hair coloring when it was found. The exceptionally beautiful faced, crowned by curls, is tilted slightly towards the right shoulder, thoughtful and lost in adolescent melancholy. The quality of the sculpting and the psychological mood mark the beginning of Classical expression. In the relief sculpture of **thoughtful Athena** (460 B.C.) the goddess, wearing a Doric peplos and a Corinthian helmet bends towards a stele while resting her left hand on her spear. The combination of tenderness and a serious air make this a splendid example of the "severe style". The nude statue known as the **ephebus of Kritios** (circa 485 B.C.), probably by the Attic sculpture Kritias, is the first example we have of a new concept in body position. The right leg is slightly bent, while the left is straight and supports the body's entire weight, creating a light, natural and spontaneous countermovement that has since characterized all Greek sculpture. Beauty, harmony, tranquility and simplicity merge together in this body which is so perfect in its proportions, and crafting, and full of an inner light. The same perfection can be seen in the **front of a horse** (490-480 B.C.). The noble animal's proud and lively movements are further emphasized by its expression. Of the relief sculptures that adorned the three buildings on the Acropolis, the **Parthenon frieze** (circa 440 B.C.) stands in a class by itself. The long marble frieze (most of it is in the British Museum) which ran along the outside of the temple and depicted the procession of the Panathenaic Festival is

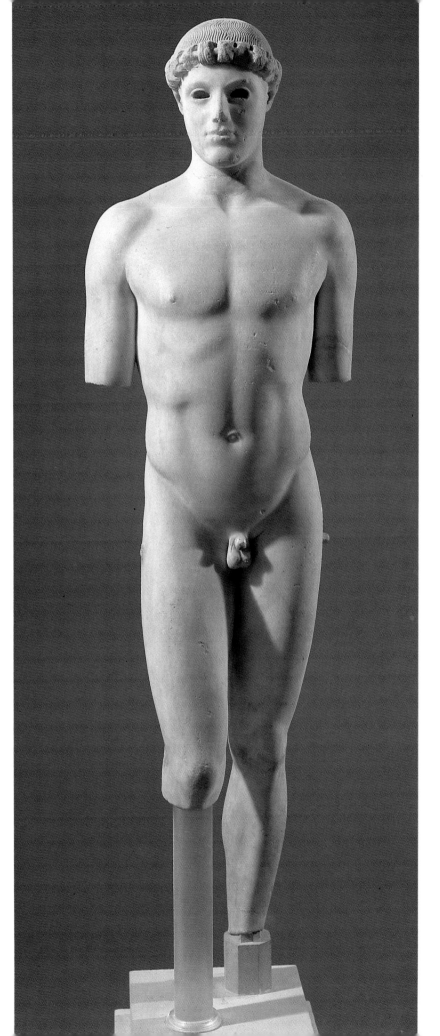

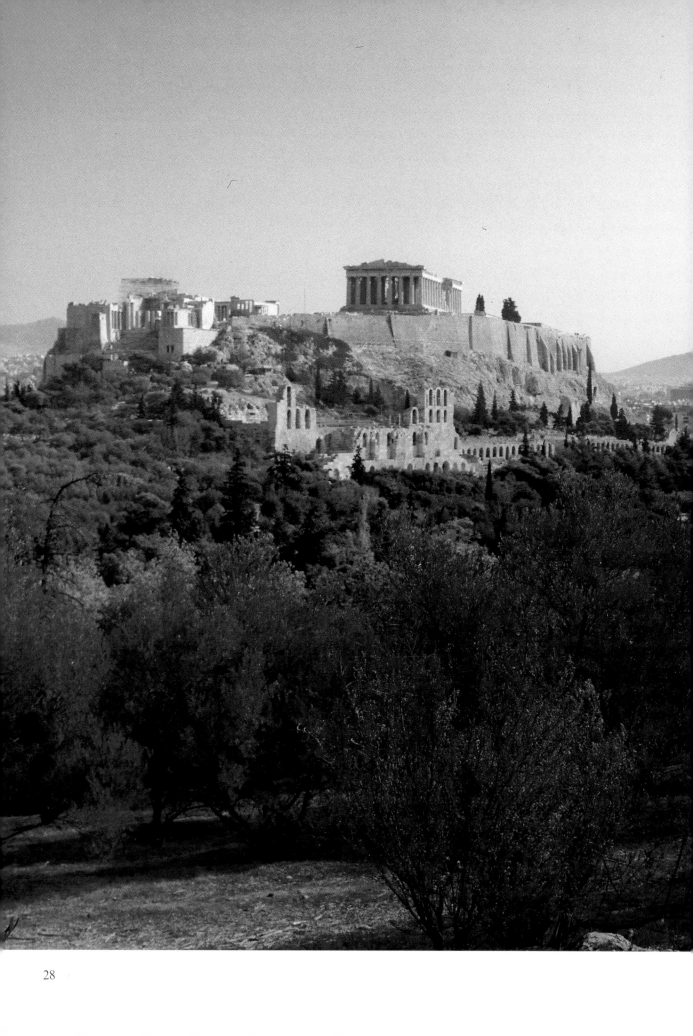

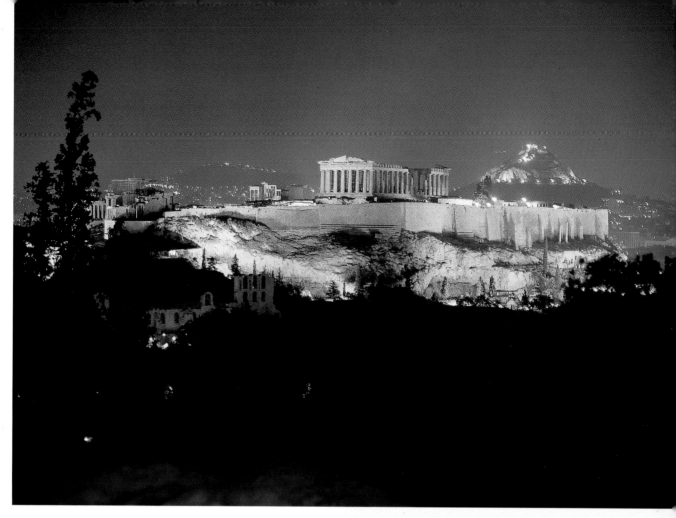

The Acropolis and its monuments under the Attic sun and during the striking "Sounds and Lights" show in the evening.

considered the greatest masterpiece of Greek art. During the festival, the greatest holiday in Athens, a grand procession of horsemen, chariots, musicians, youths and girls, important citizens and ordinary people carried the new peplos for the statue of Athena Polias and attended the sacrifice known as "hecatomb". The procession, the image of Athenian glory, passes before the gods who live harmoniously with mortals. Of the three hundred and sixty human figures and approximately two hundred animals, the **Horsemen** lend the composition a particularly festive air. In an impressive and poetic atmosphere the figures, carved in low relief, move with rhythm, reverence and discipline. The same solemn gait characterizes the **Waterbearers**. Phidias, the great artist whose name is forever linked with the Parthenon succeeded in creating an unique balance of spiritual and material strength.

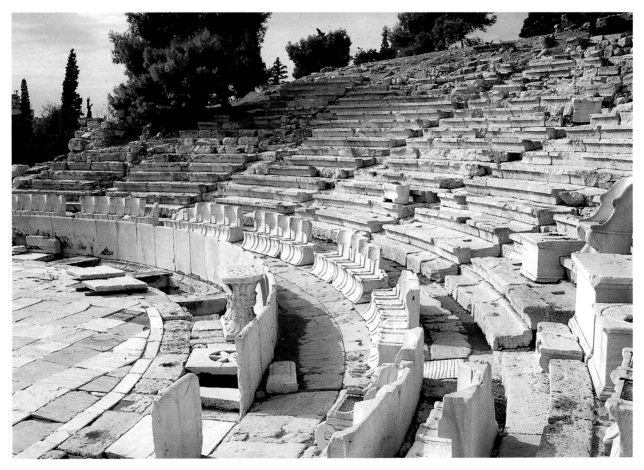

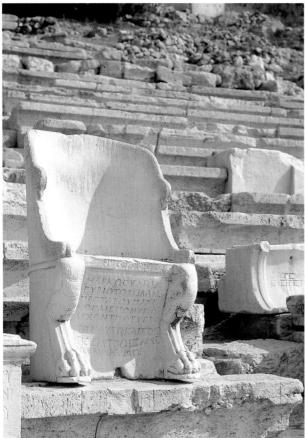

The Theater of Dionysus, detail of the audience section with its marble steps.

Marble throne with engraved inscription in the Theater of Dionysus.

The Theater of Dionysus. Part of the sculptures from the Roman proscenium.

The Theater of Dionysus seen from the Acropolis.

THEATER OF DIONYSUS

Towards the middle of an VI century B.C. a new literary genre was born in an Attic city: drama. Within the context of the democratic processes of the Athenian republic, it was continuously perfected and made part of the institution of democracy. It represented dialogue and freedom of thought, but it was also the fruit of an Archaic rural cult dedicated to Dionysus, god of fertility, wine, bliss and the sacred rituals that led the faithful to delirium, ecstasy and release from the conventional bonds of daily life. The Archaic songs celebrating the god evolved gradually. From the V century on, with the introduc-

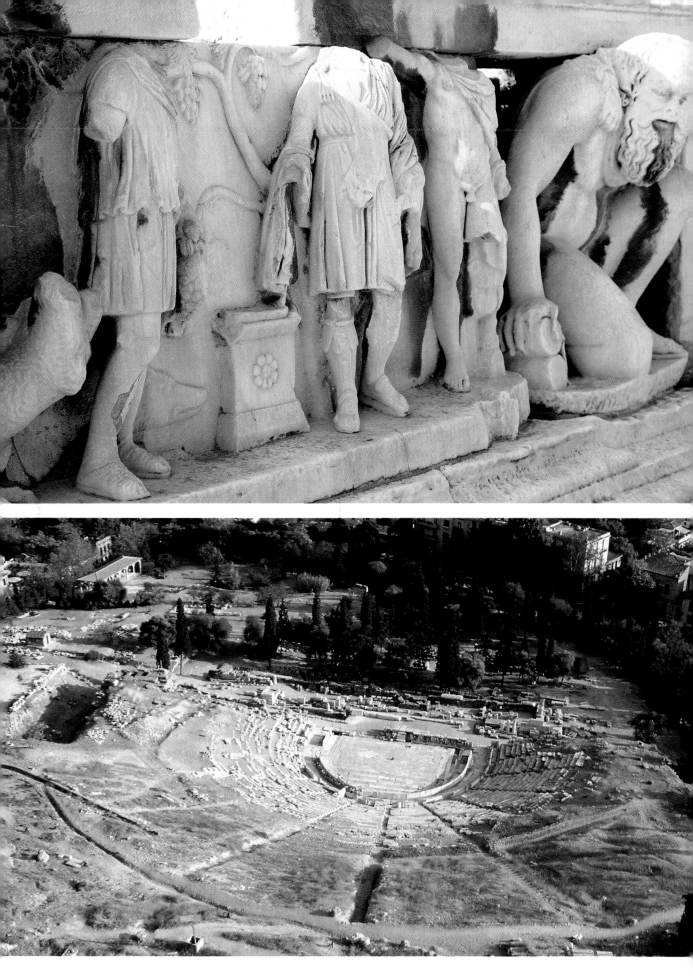

tion of the first "hypokrisis" and the dialogue with the "chorus", these religious moments formed the basis for the development of the logic and meter of tragedy, comedy and satyrical drama inspired by myths and historical events.

The **Theater of Dionysus Eleutherius**, on the southern slope of the Acropolis was the world's first theater, and its influence is evident in theaters even today. It was built in several phases, each of which corresponded, essentially, to developments in ancient drama: what we see today dates from the Roman Empire. The works of the great classic poets were performed here (Aeschylus, Sophocles, Euripedes and Aristophanes). The seating capacity was about 17,000, and the front consisted of 67 **marble thrones** reserved for prytanes and dignitaries. Today we can see **portions of the sculptures that decorated the Roman proscenium** portraying scenes from the life of Dionysus.

ODEUM OF HERODES ATTICUS

On the southwest part of the Acropolis stands the well-preserved **Odeum** named after **Herodes Atticus**, a wealthy Roman orater and teacher of Marcus Aurelius who lived in the II second century A.D. He used a great portion of his money to build public works and Panhellenic sanctuaries in his adopted home. In 160 A.D. he built the Odeum, one of the city's jewels, in memory of his wife Regilla.

The structure is typical of Roman theaters with a semicircular auditorium, monumental curved stage, three story façade, and covered *paradoi* and stairs. Today, the restored theater has a seating capacity of about 5,000 and is used for the Athens summer festival of music, drama and dance.

The Odeum of Herodes Atticus seen from the Acropolis; in the background, the Hill of the Muses and the Monument of Philopappos.

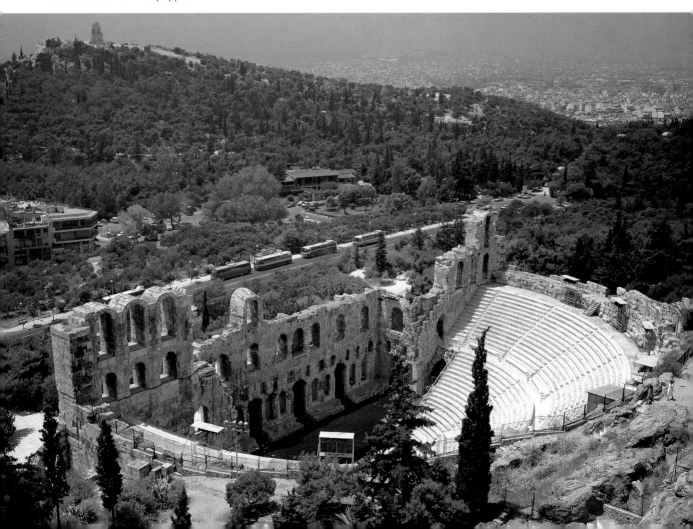

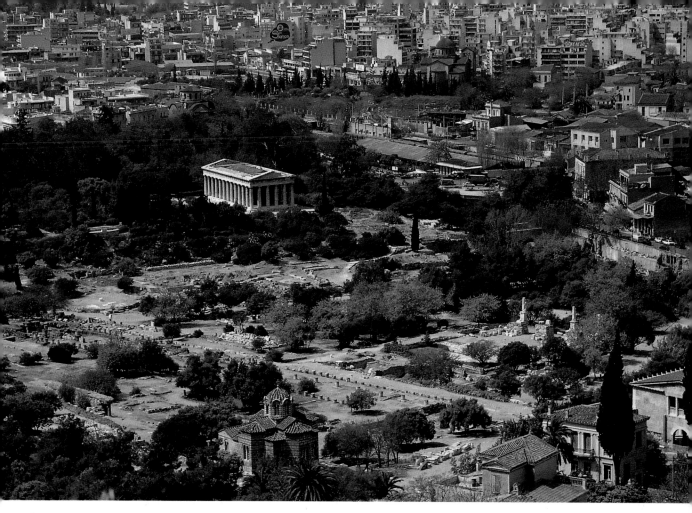

The Agora seen from the Acropolis.

AGORA

Northwest of the Acropolis, in the **Agora** there is evidence of human life from the Neolithic period to the XX century; for 5,000 years it has been the most highly frequented place in Athens.

The Agora (=meeting, assembly) was the center of public life, the place where Athenians gathered for all political, religious, economic, cultural, athletic and theatrical events. It was the site of not only trade and commercial exchange, but also the seat of administration and justice, the right setting for social interchange, for worship of the gods and spiritual development. This multiple role in relation to Athenian life was documented by the ancient historians like Xenophon, politicians and orators like Demosthenes, Lycurgus and Aeschines, poets such as Aristophanes and the philosophers Plato and Aristotle. This point was the fulcrum for all cultural and spiritual developments in a democracy that exalted the individual as its greatest asset: a being with specific rights and duties. Democracy held freedom as the greatest treasure of all.

Human presence from 3,000 B.C. to 700 B.C. is documented by various finds (objects, amphorae, graves, wells and traces of building foundations). The first embryo of the Agora began to take form early in the VI century. From 500 B.C. on, that is during the period of Cleisthenes' reforms, work began on buildings that were to satisfy the needs of public life. After the Persian invasion (480-479 B.C.), many buildings were repaired and others newly erected. In the last thirty years of the V century, the construction of a group of public buildings in the Agora created the basis for its future overall appearance that would be completed during the years Lycugus controlled the city's finances. A further renovation, sponsored by the Roman emperors in the II century B.C., put the final touches, as it were, on the Agora. The first great destruction took place in 86 B.C. when the Roman general Sulla captured Athens. Many new public buildings were put up in the following years and were to stand until 267 A.D. when the Agora was abandoned following

33

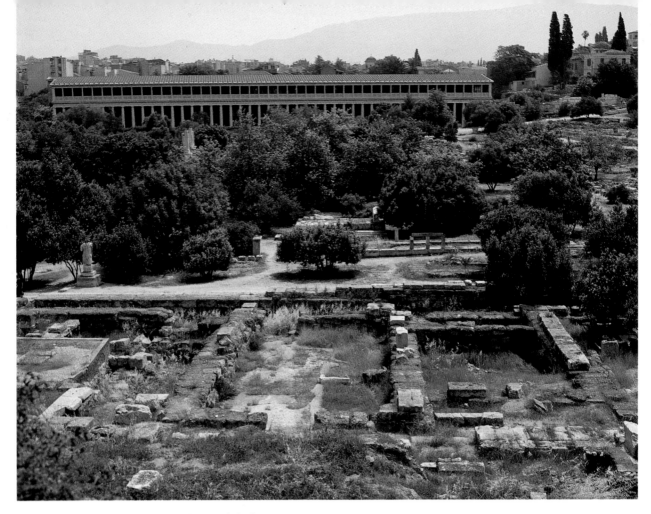

The Stoa of Attalus seen from the Theseum, in the foreground the ruins of the Metroum.

the destruction wreaked by the Heruli. The area was inhabited and life had a new start in the early years of Christianity, and this was to last until the Barbarian invasions of the VI-X century A.D.

During the Byzantine Empire and throughout the Frankish and Ottoman dominations the Agora was a residential area. In 1859 the first archeological excavations were begun; in 1931 the last homes were torn down and the excavations reached considerable depth: the systematic research begun then is still in progress.

On the western side of the hill of *Colonos Agoraios* is the **temple of Hephaestus and Athena**. Both divinities were worshipped as patrons of the arts and trades. Work on the Pentelic marble temple was begun in 449 B.C., and since part of sculptural decorations depict the exploits of Theseus it has become known as the **Theseum**. Inside there were votive bronzes of the gods by Alcamenes, pupil of Phidias. During the Christian period the temple was transformed into the *church of Aghios Gheorghios* (St. George). It was here that Athens was pro-

claimed capital of the new Greek nation in 1834. This Doric temple with Ionic elements and graceful elegance is the best preserved monument of the Agora. It is also the only ancient temple which can be admired as it was in antiquity, that is, in the midst of a small sacred wood next to the modern city. On the western side of the Agora one can also see the foundations of the *Basileios Stoa* or *Stoa of Zeus* that dates from the V century. This is one of the places Socrates frequented, and where the Areopagus met (it is here that the great philosopher was tried). Here are also the remains of other important public buildings: the **Metroum** (II century) that contained the state archives; the *new Bouleuterion* (around the beginning of the V century) where the Council of Five Hundred, that presented the reports of the Assembly met; the *Tholos* (circa 460 B.C.) where a set of standard weights and measures were kept, and which hosted the Prytaneis, representatives of the parliament. The statue of the Eponym Heroes (IV century B.C.), that is the legendary Attic heroes stood opposite the Metroum on several altars. On the south side stood the *Heliaia*, seat of the famous people's tribunal, the *Fountainhouse*, the

34

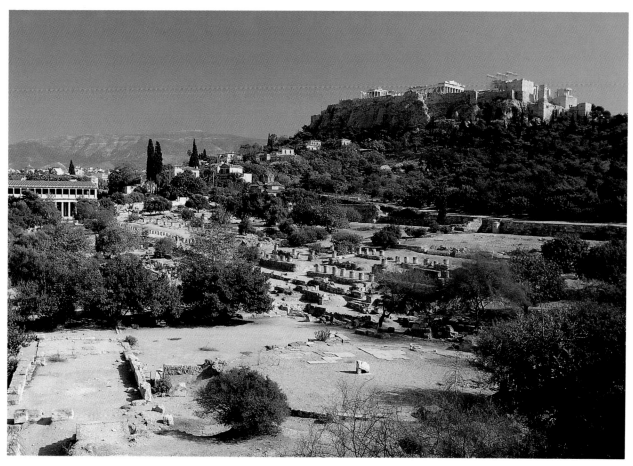

A view of the Agora towards the Acropolis.

The Agora reconstructed in the II century A.D.

Mint and three long porticoes. In the central area rose the *Temple of Ares* (V century B.C.) brought from Acharnai, the *Altar of the Twelve Gods*, a place of asylum, and the *Odeum of Agrippa* (15 B.C.). Colossal marble statues were added to the façade of the Odeum after 150 A.D. The eastern side of the Agora is bounded by the restored **Stoa of Attalus** (II century B.C.), the *Library of Pantainus*

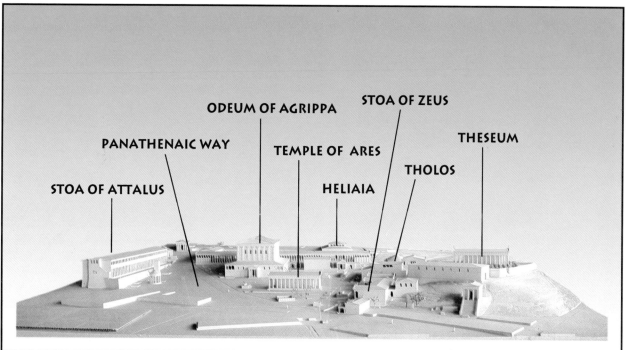

STOA OF ATTALUS
PANATHENAIC WAY
ODEUM OF AGRIPPA
STOA OF ZEUS
TEMPLE OF ARES
THESEUM
HELIAIA
THOLOS

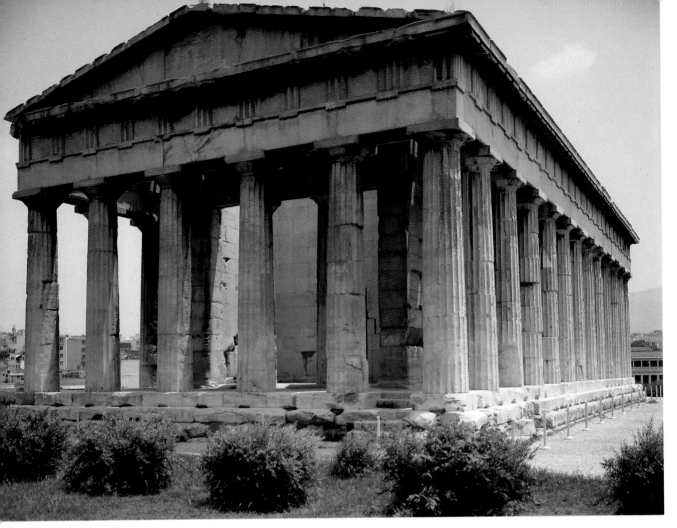

The southwest side of the temple of Hephaestus and Athena known as the Theseum.

The temple of Hephaestus and Athena (Theseum), detail of the eastern side.

View of the Agora, the central area and west side are clearly visible. In the background, the Keramikos and part of the districts west of Athens towards Egaleus.

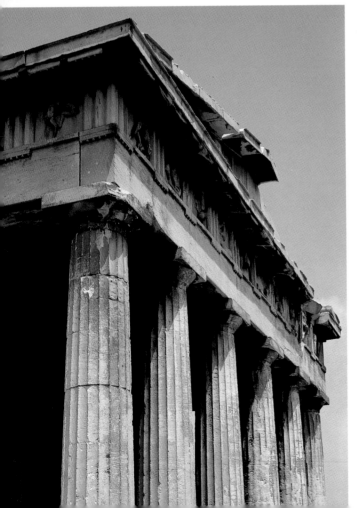

(100 A.D.), and the *Panathenaic Way* which, starting from the Diplyon of the Keramikos diagonally crossed the Agora and led towards the Acropolis. The only standing Byzantine monument in the Agora is the **Church of the Holy Apostles** (XI century). This is a cruciform structure, that is with four central columns, narthex, marble iconostasis and floor. It was restored between 1954-56; the frescoes inside date from the XVII century.

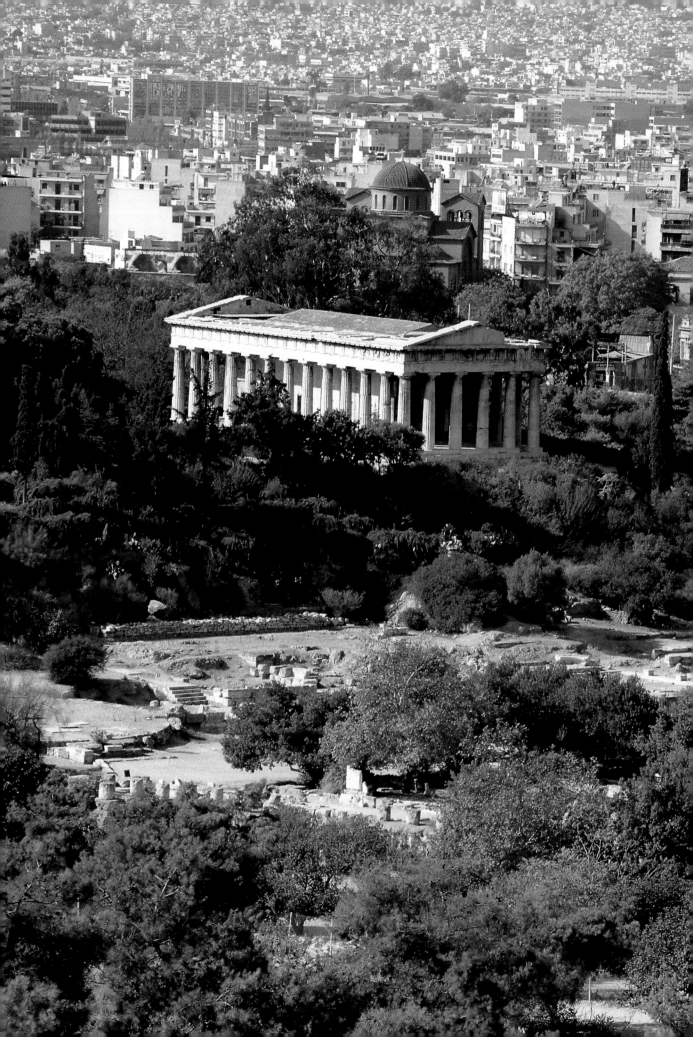

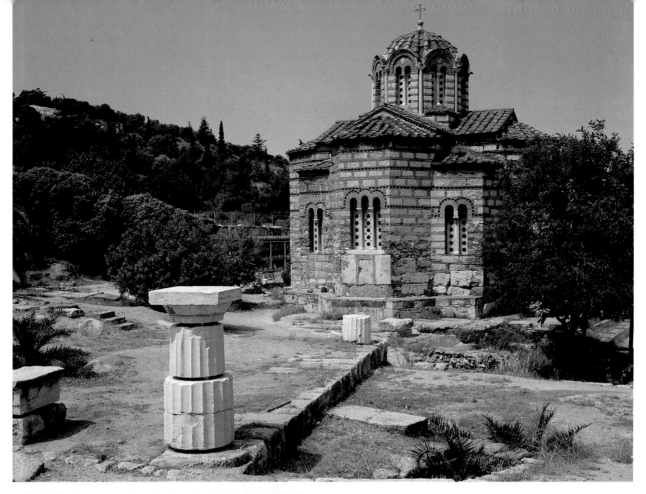

The restored church of the Holy Apostles (ca. 1000).

Interior view. The frescoes date from the XVII century.

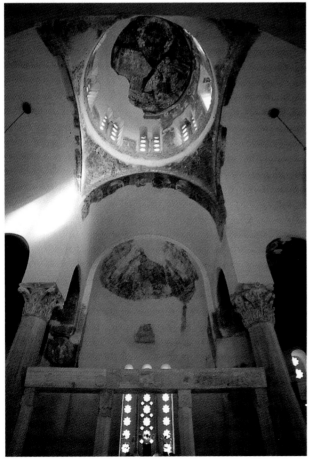

THE AGORA MUSEUM

The rich findings in the excavations on the Agora were located in the Stoa of Attalus (II century B.C.), founded by Attalus II, king of Pergamum and was completely rebuilt by the American Archeological School in 1953-56. Originally a trading center and place for leisure, the stoa had a series of shops which the state rented to private merchants. The items on display, closely related to the trading, political, religious and cultural activities of the place cover the full span from the Neolithic to the Ottoman periods. Among the artifacts from the period dating from IV millenium and the VII century B.C. is the entire Protogeometric tomb of a young girl complete with funerary objects (1000 B.C.); a child's terracotta potty and a pair of boots. The items from the VI century on and related to the political life of the Agora include the **pottery shards** *(òstraka)* used in when voting for ostracism or banishment with the names of Aristides, Themistocles and Chimon as candidates for ostracism as they were suspected of wanting to undermine the Athenian democracy. A very interest-

ing display is the set of **metal standard weights** with symbols and wording indicating the units; there are also the **terracotta standard weights and measures** determined by the Agoranomia. There are also many objects used in judicial proceedings such as the **terracotta clepsydra** used to measure the time allowed for pleadings; bronze voting discs with a vertical trunk (full for acquittal, empty for guilty sentences), to guarantee secret voting by the judges; and the marble *kleroterions* (devices with slots where lead plates with the citizens' names were inserted to assure the anonymity of the members of the court in trials). Finally, there is a collection of household items from different periods which bear strong resemblances to current utensils: terracotta grills, portable ovens and an ingeniously made child's terracotta chair. On the ground floor there is a sculpture exhibit that includes the enormous headless statues of Apollo Patroos by Euphranor (IV century B.C.) two Roman statues of women, statues of scenes from the Iliad and the Odyssey and finally the interesting **marble stele inscribed with a law against tyranny passed in 336 B.C.** The upper part of the stele comprises a relief sculpture representing Democracy crowning a seated man, that is the people of Athens. On the first floor, the scale models of the Agora, the Stoa of Attalus, the Acropolis and the Pnyx are among the highlights of the exhibits.

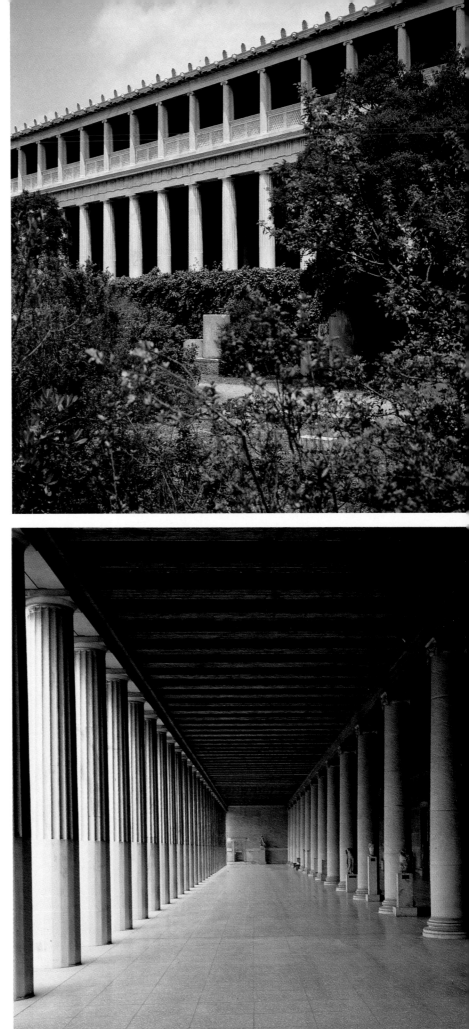

Part of the rebuilt Stoa of Attalus.

View of the colonnade inside the Stoa of Attalus.

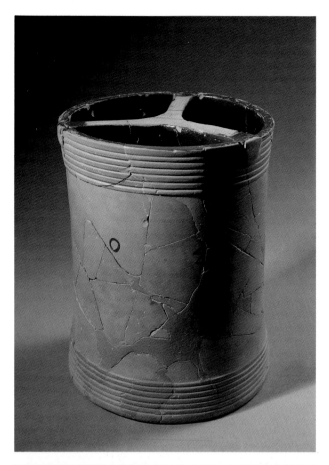

The terracotta standard weights and measures.

Pottery shard (ostraka) used in voting for ostracism.

Terracotta clepsydra and bronze voting discs.

Example of a marble kleroterion.

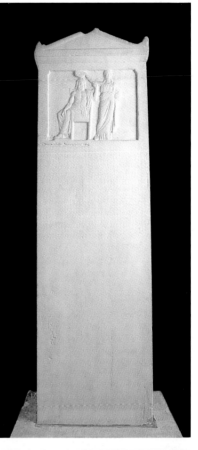

Stele with the ruling against tyranny dated 336 B.C.

Detail of a red-figured vase showing a scene of everyday life.

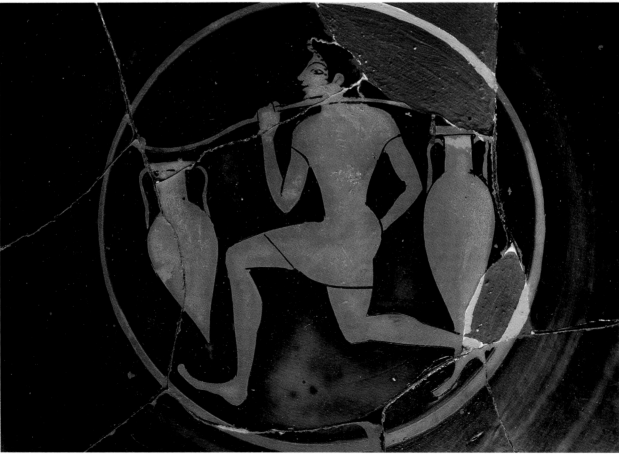

41

TOWER OF THE WINDS

The **clock of Andronicus Cyrrhestes** or **the Tower of the Winds** is a small structure built of Pentelic marble (I century B.C.) that contained the clock that ran on water from the spring on the Acropolis, and had an iron weather vane at the top of the pyramidal roof. The outer walls were decorated with relief carvings of the eight winds, each depicted holding a special symbol, and with its name on the cornice. With the advent of Christianity the building was transformed into a church or baptistry, and then, in 1750 it became a *tekke*, an Ottoman place of worship (tekke of the Whirling Dervishes). It is located in the **Roman Agora** that was built by the emperor Augustus.

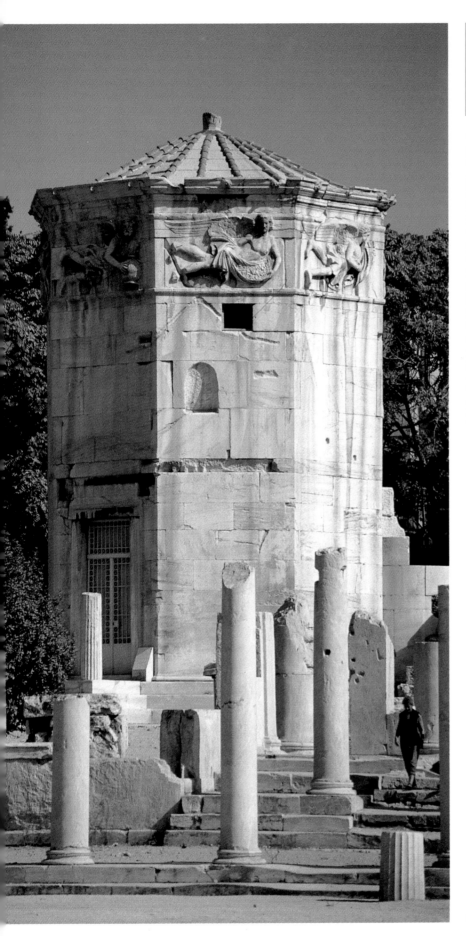

The clock of Andronicus Cyrrhestes, or the Tower of the Winds.

THE ROMAN AGORA

The **Agora** was home to Athenian trade until the
XIX century. The large Roman market, a big square
flanked by columns with its stores and public build-
ings was directly linked to the Greek Agora by the
Gate of Athena Archegetis. During the Turkish
domination it was still used for trade, and the gate
was known as the "Gate of the Bazaar". From the
golden days of Classical Athens to the disastrous
fire of 1884 the site had continuously been used as a
market: the city's heart beats in the same place.

The Roman Agora with the Gate of Athena Archegetis.

*On the following pages: panorama of the Acropolis and the
Hill of Lykabettos in the background.*

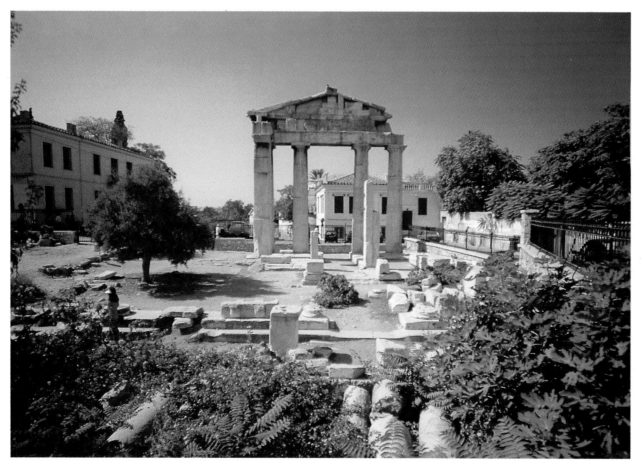

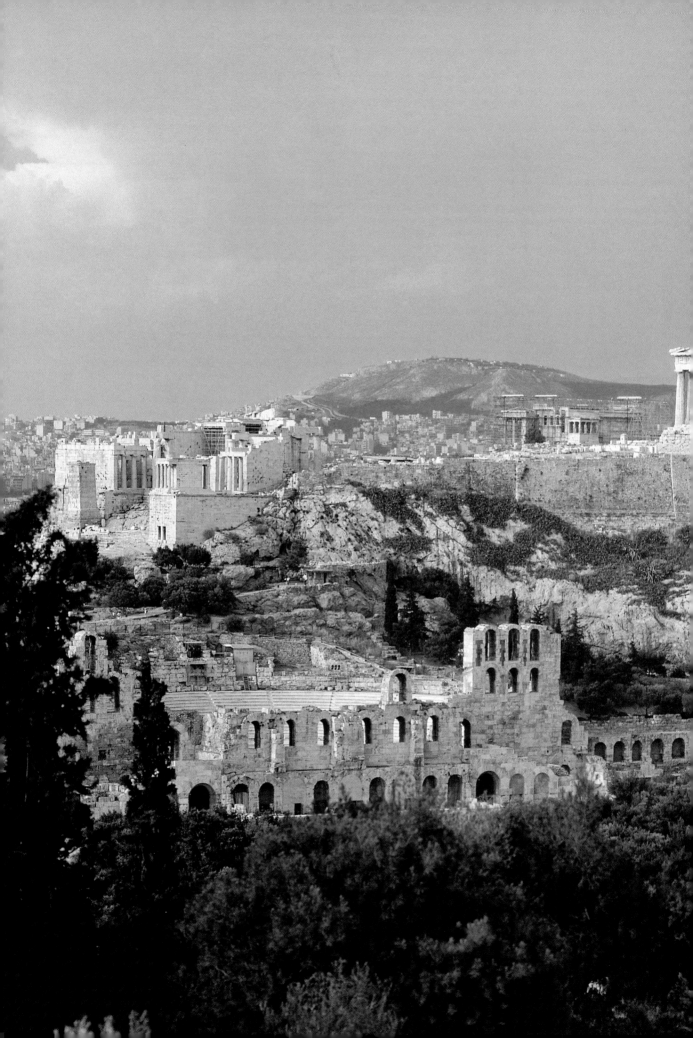

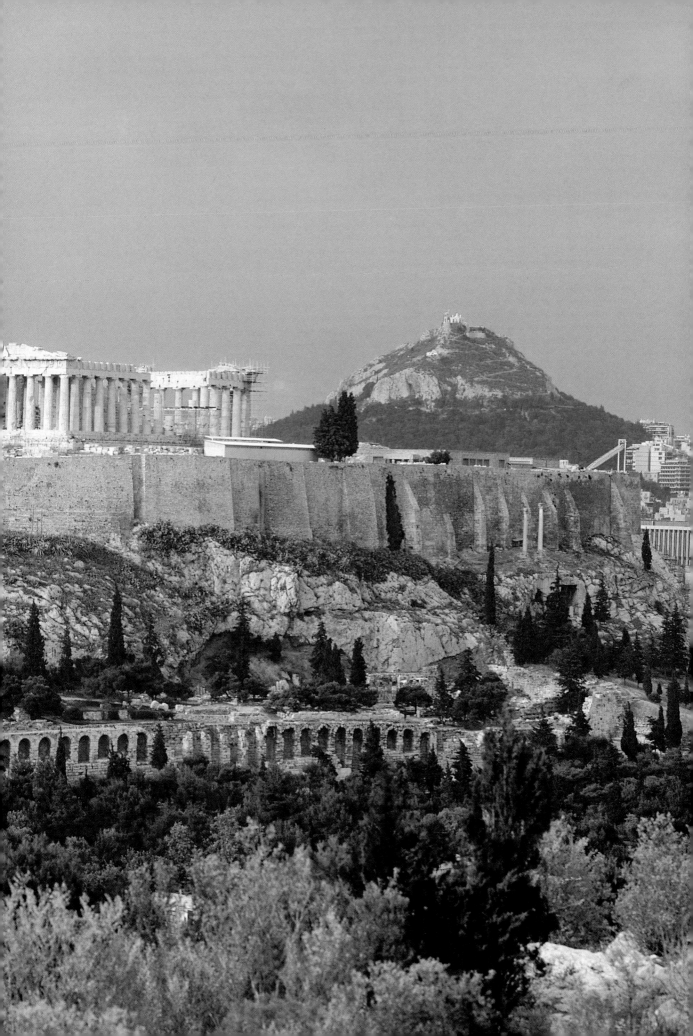

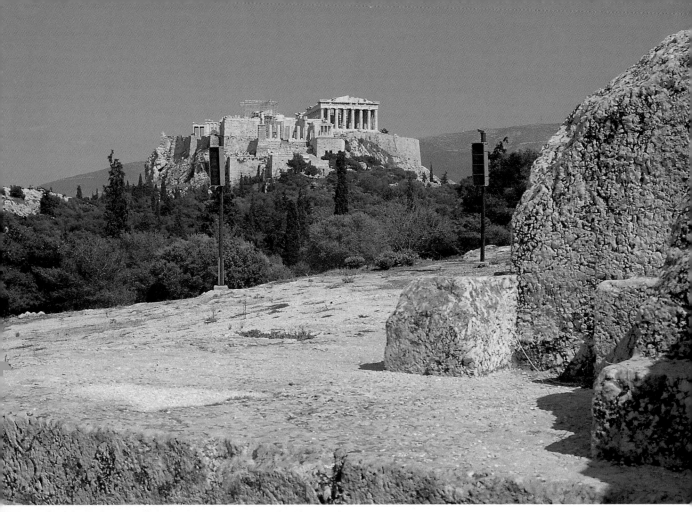

The Hill of the Pnyx.

Twilight on the Saronic Gulf seen from the hill of Philopappos.

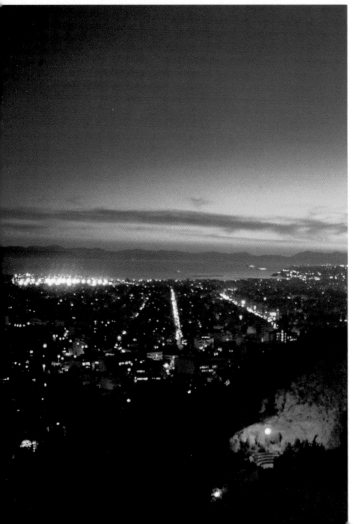

HILL OF THE PNYX

This hill, which formed a natural amphitheater on the northeast slope was the heart of Democracy. This place, where "Sound and Light" performances are held, used to be the meeting place of the Ecclesia or Assembly, the supreme institution of the Athenian Democracy.

From the Bema, or tribune carved into the rock, politicians, orators and common citizens spoke to assemblies of six thousand citizens, the number required for a quorum. Inspired by the monuments of their city on the nearby hill of the Acropolis, great statesmen such as Pericles, Themistocles, Aristides and Demosthenes spoke and proposed laws, alliances, war and peace. It was here that the great decisions determining the fate of their city were made.

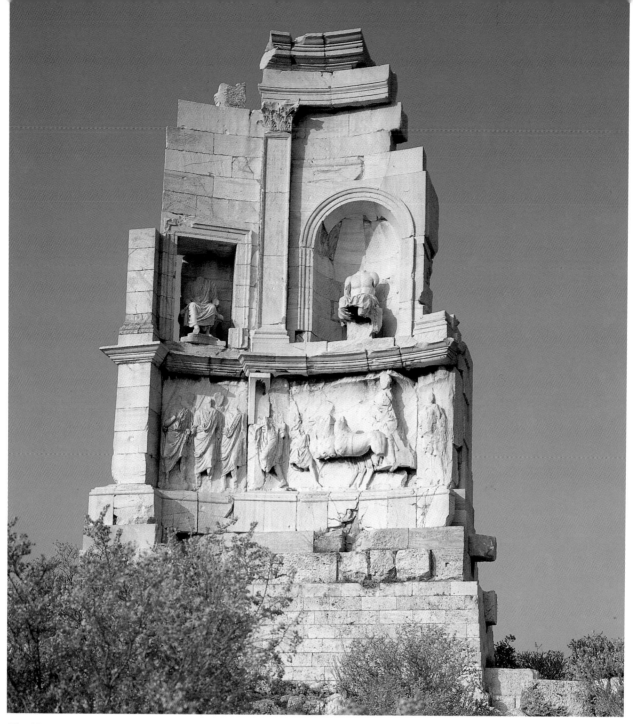

The Monument to Philopappos on the Hill of the Muses.

THE HILL OF THE MUSES

To the southwest of the Acropolis rises a little, pine clad hill. On the summit stands the **burial monument**, built in 119 A.D., in honor of C. Julius Antiochus **Philopappos**. It was the Athenians way of expressing their gratitude to a generous citizen of Syrian origin who, as Roman consul had distinguished himself by building many monuments and passing decrees for the good of the city. The central niche contains the statue of Philopappos as an Athenian citizen seated on a throne. Below, in the middle of a high-relief frieze is Philopappos as consul driving in his chariot.

The view from the monument is truly spectacular: to the north rises the Acropolis in all its grandeur, the Pnyx and the Areopagus hills, in the distance, the Lykabettos the highest of the Athenian hills, and on the horizon the Pentelicus and Parnis mountains; to the east the Olympian, the Ardettos and Hymettos hills; to the south, the Saronic Gulf and on the west the Piraeus and the mountains of Salamis.

47

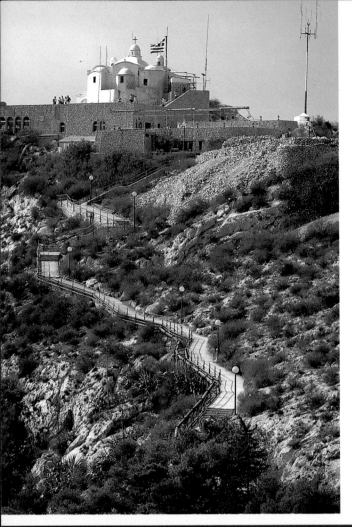

LYKABETTOS

The **rocky hill of Lykabettos** (277 m.) was already mentioned by the ancient writers. With its pre-Hellenic name, and pine covered slopes, after the Acropolis it is the most distinctive landscape feature of the Attic plain. It offers an extraordinary view in each direction, from the Saronic Gulf to Parnis, Pentelicus, Hymettos and Aigaleon. At the top, stands the little white **chapel of St. George**, built in 1834 when Athens became capital of the new nation. In the middle ages there had been a small church dedicated to the prophet Elijah, as we often find on Greek hilltops. In 1965 a new road was opened leading to the outdoor theater where performances are held nearly every evening in the summer. In the same year, a cable railway that goes right through the mountain was built; it quickly makes the trip to the top where there is a fine view of the Attic plain.

The chapel of St. George at the top of the Lykabettos hill.

A panorama from Lykabettos: the Acropolis, the hill of Philopappos, Piraeus and the Saronic Gulf.

Lykabettos at night.

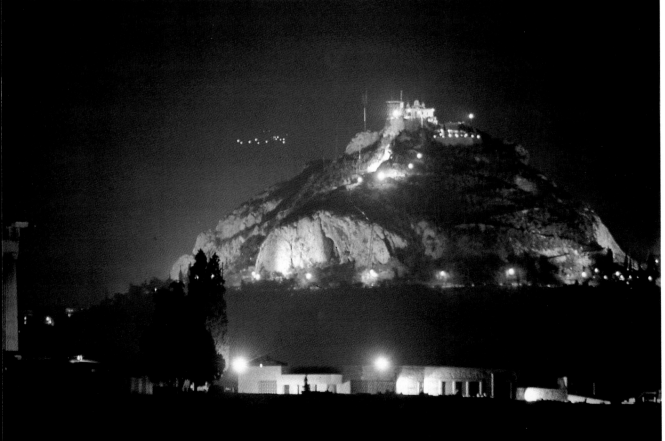

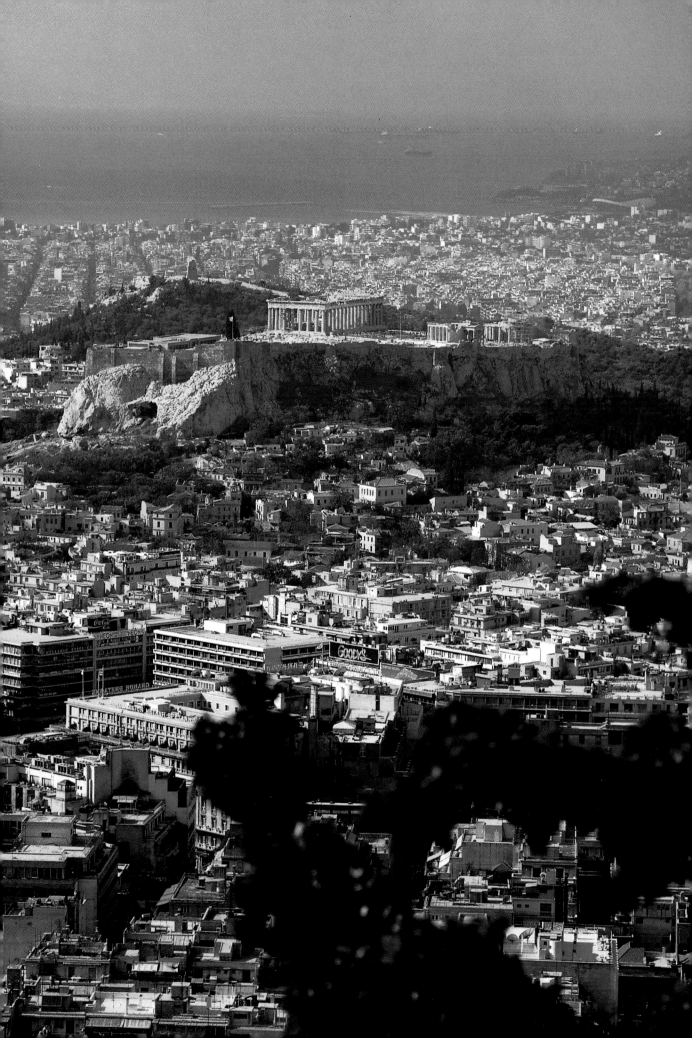

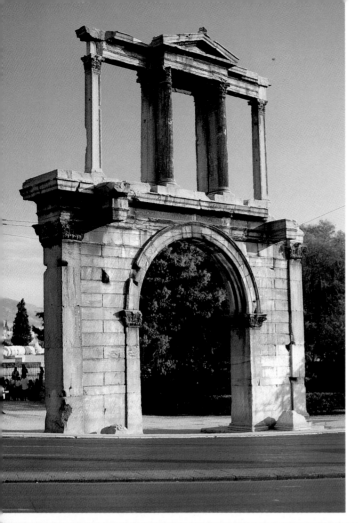

THE TEMPLE OF OLYMPIAN ZEUS AND THE ARCH OF HADRIAN

The area of the Olympeion, near the Ilisos river and the Kallirrhoe Spring was closely linked to the life giving element, water. During droughts, from antiquity to the Ottoman period, the inhabitants of the Valley would come here to ask the gods for help. Work on the first, huge Doric temple, dedicated to Olympian Zeus was begun by Peisistratos in 515 B.C., and was never finished. In 174 B.C. Antiochus Epiphanes IV, king of Syria resumed building to new plans by the Roman architect Cossutius who maintained the original dimensions (107 x 41 meters) but substituted the Corinthian for the Doric order and increased the number of columns.

Arch of Hadrian.

Columns from the Temple of Olympian Zeus.

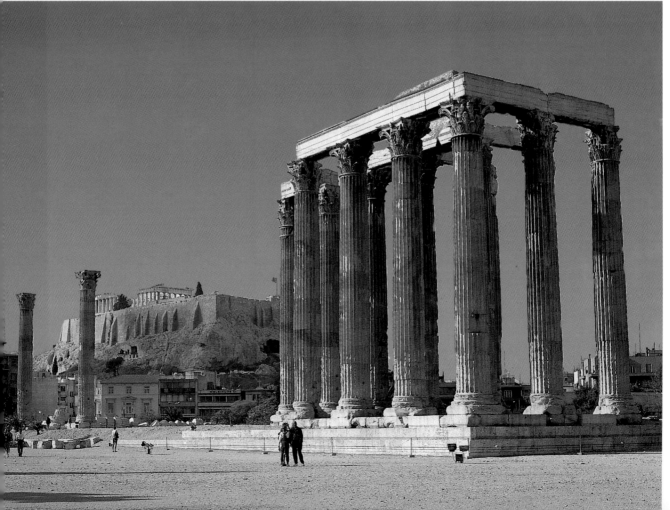

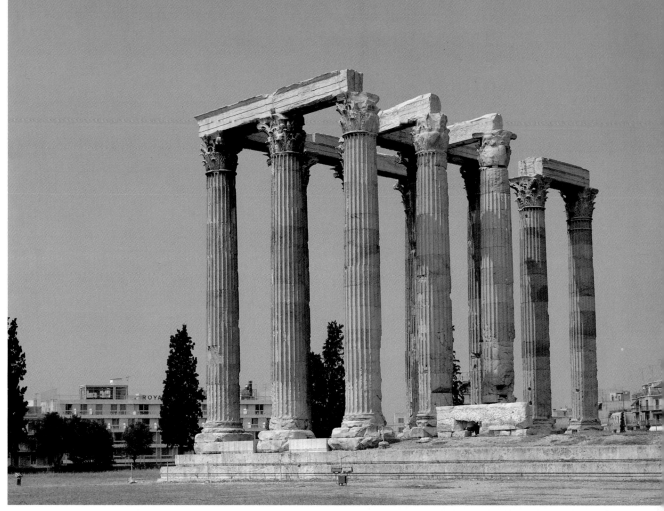

The eastern side of the temple of Olympian Zeus.

Detail of the Corinthian columns.

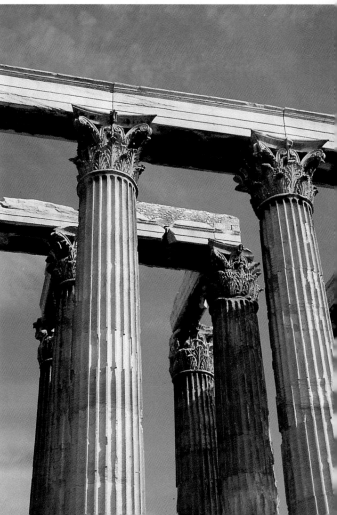

However, this work was also interrupted. In 86 B.C. Sulla had some of the shafts taken to Rome for the Capitoline Temple of Jupiter, which brought the Corinthian style to the West. Finally, in 124-125 A.D. the emperor Hadrian completed the temple which was consecrated in 131 A.D. Two chryselephantine statues, one dedicated to Zeus and the other to Hadrian himself were set up within the cella. Of the originally 104 grandiose columns, only 16 remain today.

The **Arch of Hadrian** was built by the Athenians during the same period to honor Hadrian, a great patron of the Greek spirit. It divided the ancient city of Athens from the newer, Roman, portion as the two inscriptions on the gate itself state.

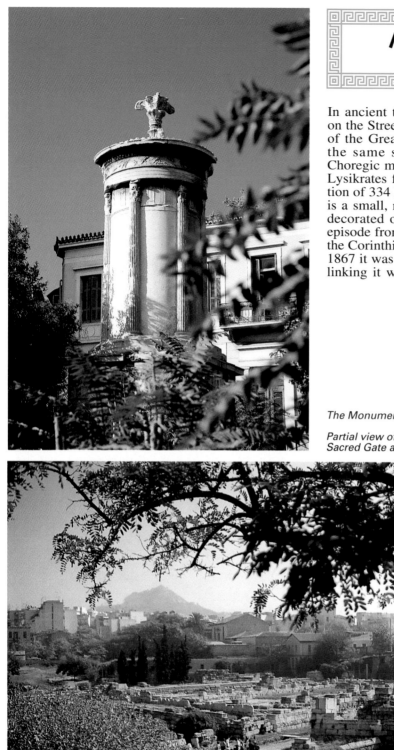

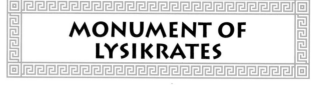

MONUMENT OF LYSIKRATES

In ancient times the choregi placed bronze tripods on the Street of the Tripods to celebrate the winners of the Great Dionysiac drama festivals. Today, in the same street of the Plaka district, the only Choregic monument in good condition is the one to Lysikrates for the victory in the theatrical competition of 334 B.C. as we can read on the inscription. It is a small, round building with Corinthian columns decorated on the outside with reliefs depicting an episode from the story of Dionysus and carved from the Corinthian capital up to the top of the roof. Until 1867 it was known as the "Lantern of Demosthenes, linking it with the great Athenian orator. From the

The Monument of Lysikrates.

Partial view of the Keramikos with the Diplyon, the Sacred Gate and the Pompeion in the background.

eighteenth century onward it was also known as the "Lantern of Diogenes". From 1669-1821 it belonged to the monastery of French Capuchin monks, first used as a chapel and then it was incorporated into the convent library. Many foreign guests stayed there such as Chateaubriand and Lord Byron, who portrayed it in drawings and engravings. The monument even ran the risk of being moved to England. It was restored in 1892.

KERAMIKOS

A short distance to the northwest of the Agora is the ancient **Cemetery of the Keramikos**. The place gets its name from Keramos, son of Dionysus and Ariadne, and patron of the potters (ceramists) who had their workshops here. It was used as a burial place already in the third millenium B.C., and with the exception of the years from 1500-1200 it was used for burying and cremating the dead until the VI century A.D.

The excavations at Keramikos offer a clear picture of the site and its monuments. Beyond the Wall of Themistocles and along the road that led from the outskirts to the double gate of Athens, the **Diplyon**, was the *Démosion Séma* or *Polyandrium* where famous Athenians and common citizens who gave their lives for their country were buried. Along the Street of Tombs and the Sacred Way (*Ierà Odòs*) that leads to the **Sacred Gate** tombs of ambassadors and famous citizens decorated with elegant, elaborate stele have been uncovered. Initiates of the Eleusinian rites began their processions from the Sacred Gate, while the procession for the Panathenaic Festival started from the nearby **Pompeion**.

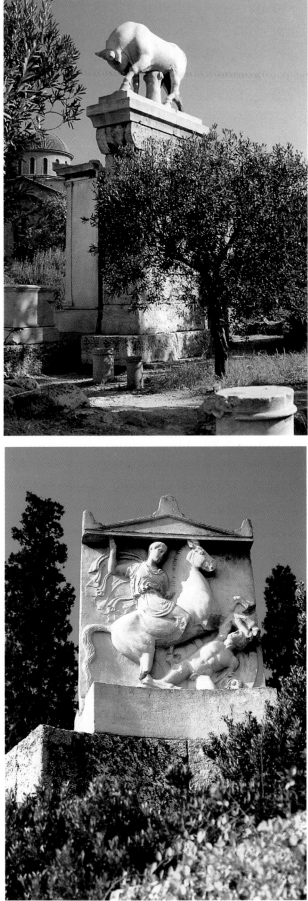

Statue of a bull. Funerary monument of a family from Heraclea.

Copy of the funerary stele of Dexileos.

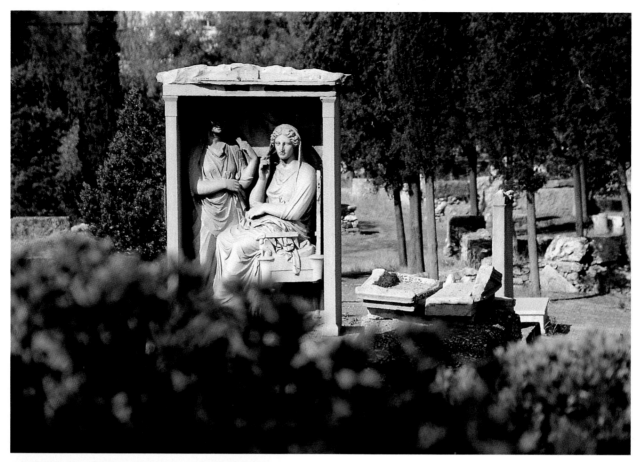

Funerary stele of Demeter and Panphila.

A group of funeral monuments in the Chorebus courtyard. On the left a copy of the famous stele of Egeso (the original is in the National Archeological Museum).

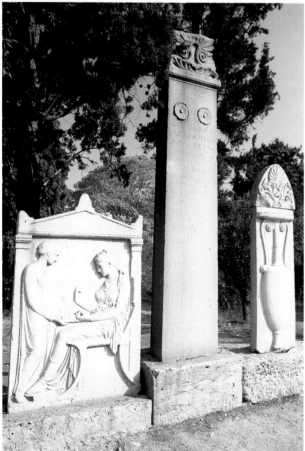

KERAMIKOS MUSEUM

The Keramikos Museum contains objects uncovered during the excavations at the ancient necropolis. There are many ceramic items from various periods. The Geometric period is represented by different shaped vases and terracotta objects. Of particular interest are the cinerary urns from the XI century B.C., the oldest iron sword (XI century), the vase with an iron sword around its neck according to a custom of the period and the vessels with horse-shaped handles.

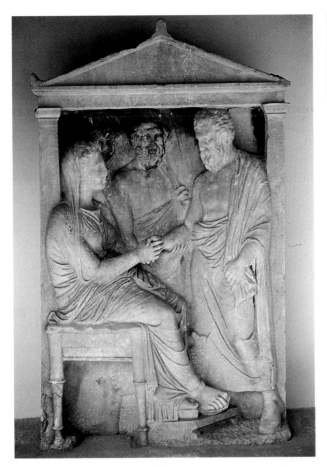

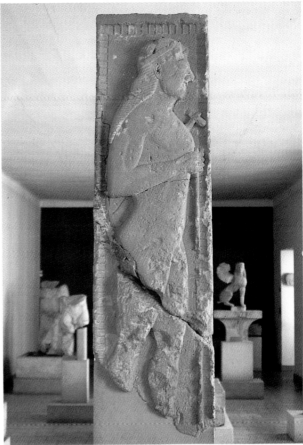

Funerary stele in the shape of a temple, with a scene of farewell.

Archaic funerary stele portraying a man with a sword and staff.

Vase with reliefs of mourning women, sphinxes, serpents and other funerary symbols (VII cent. B.C.)

From the Archaic period there is a noteworthy amphora by the painter of Piraeus (650 B.C.), **vases with reliefs of mourning women, sphinxes, serpents and other funerary symbols** (VII century B.C.), and the **hydriae** or water jars **with scenes of mourning** (560 B.C.).

The most remarkable funerary monuments include the **stele of a man holding a sword and staff** made of poros (570-560 B.C.), the sphinx-shape stele (550 B.C.), the **Memorial of Dexileos** (early V century B.C.) and the stele of Anpharetes (late V century B.C.).

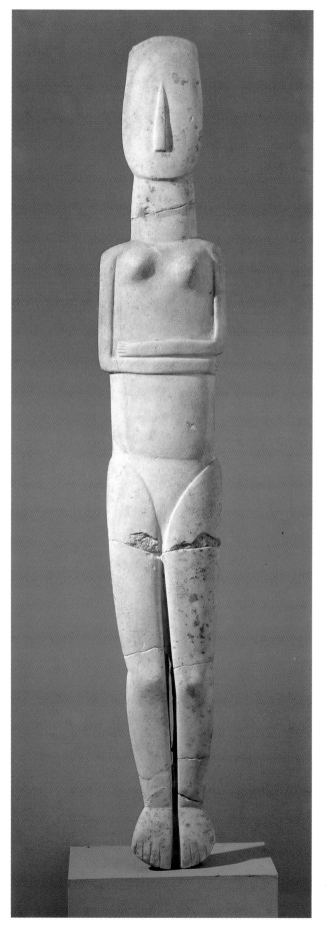

Construction work on the National Archeological Museum began in 1866 and was completed in 1889. The land was donated by Eleni Tositsa and the work was financed by Demetrios Bernardakis. The architect Ludwig Lange drew up the original plans which were modified by Ernst Ziller. The museum was expanded between 1935 and 1939, while the exhibits were finally completed after World War II. Ancient Greece is finely represented in the world's greatest collection of authentic sculptures and pottery from all historical periods. The collections of prehistoric items from Thessaly, the Cyclades, the island of Thira and other great centers of Mycenaean civilization, and the small masterpieces in gold and bronze, and the ancient coin collections further enrich the Museum.

CYCLADIAN CIVILIZATION

In the third millenium B.C., these islands in the middle of the Aegean Sea were the cradle of the first significant European civilization characterized by the development of metal working, navigation, and a distinct artistic development. Marble, a material that abounds on these islands, provided the inspiration for the inhabitants who carved it with incomparable skill, creating the great masterpieces of the period. The marble idols, mostly females, seem to conceal the secrets of their roles in their enigmatic positions. These fascinating figurines were also found on other islands and outlying regions of the Greek world. The life-sized **female idol** from the island of Amorgo gives a hint of its probable ritual function in the careful symmetry of the body. The cleverly conceived **marble idol of the lyre player** expresses the concentration and intense feelings of a musician in the complex harmony of the curves and the head tilted up towards the light. The **idol of the flute player**, though simpler, in no way detracts from the crafting that reveals an incredible artistic sense. The **violin shaped idol**, made of marble in an earlier period, represents a human figure in a man-

Large marble idol of a woman.

Marble idol of a lyre player.

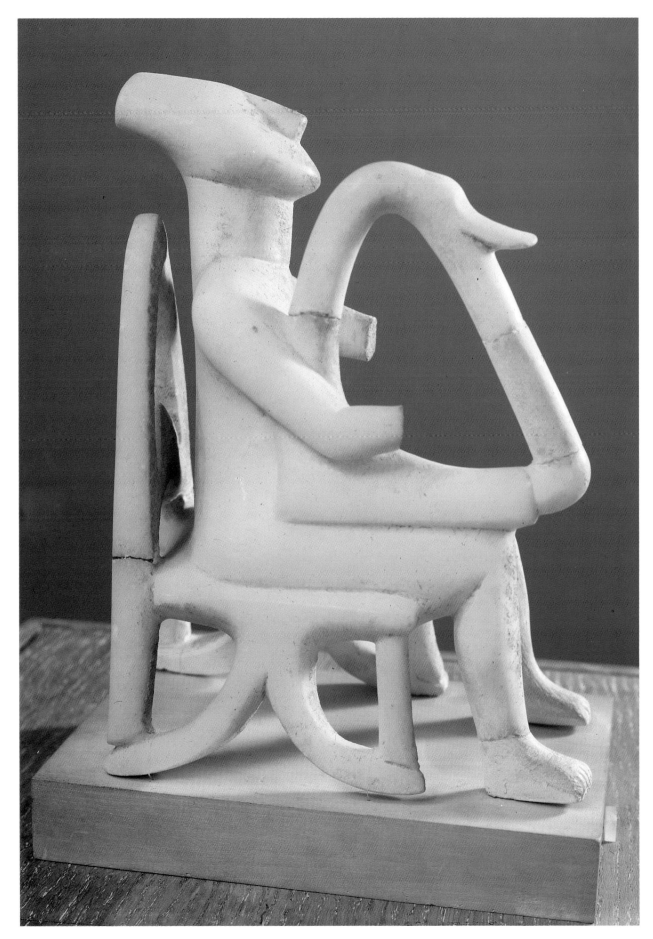

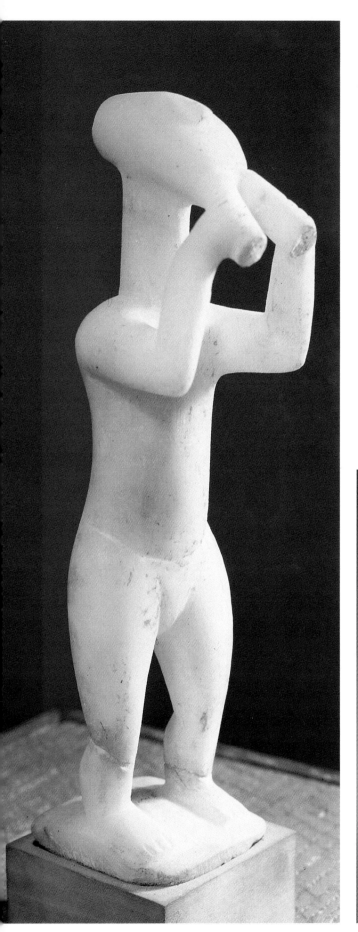

ner that recalls modern sculpture. The terracotta **animal-shaped vase** with engraved decorations was probably used for religious rites, while the **pan-shaped item** with its carved spirals is one of the many strange and mysterious items found in the tombs with the figurines. The small **lamp-shaped krater**, carved from a single block of marble, is a concentrate of the grace, purity and splendor of this island civilization that flourished during the Bronze Age.

Marble idol of double-flute player.

Animal-shaped vase.

Small lamp-shaped krater.

Terracotta pan-shaped utensil.

Violin-shaped idol.

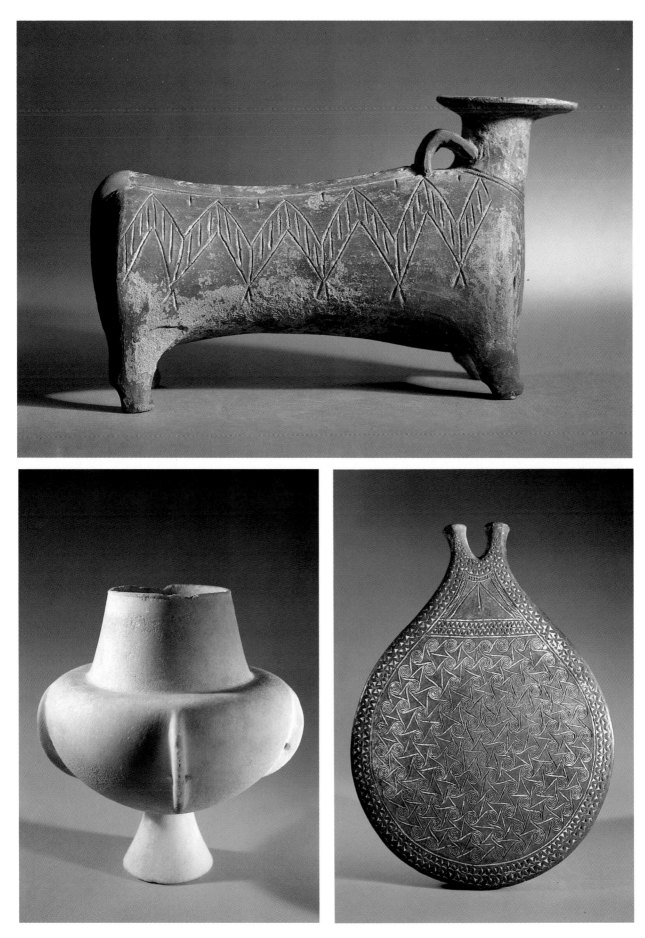

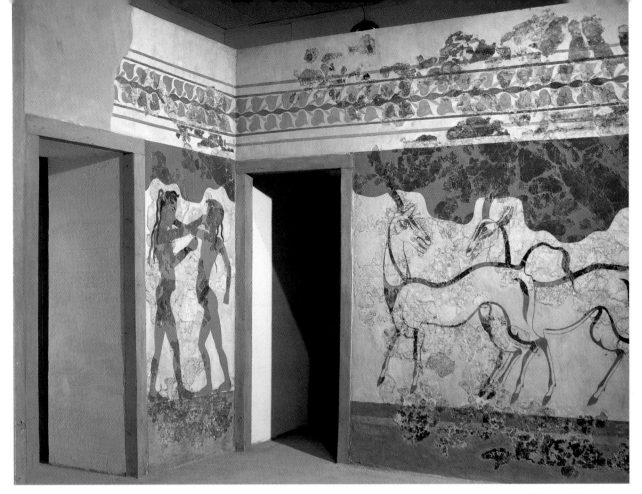

Frescoes in room B1: note the painting of the antelopes and that of the boxers.

"The Fisherman".

Fresco of the boxers.

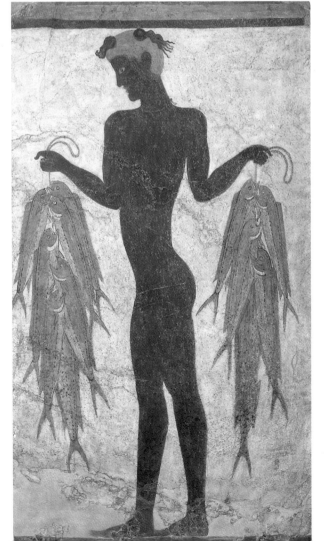

THE FRESCOES FROM THIRA

The Minoans from Crete settled on the ruins of a prehistoric Cycladian site on the southern part of the island of Thira, and brought with them the seeds of economic, social and cultural changes for the entire region. A sudden volcanic eruption in 1500 B.C. covered the entire island with a thick layer of ash which contributed to the excellent conservation of the frescoes that decorated the houses. The **fresco of the young boxers** depicts two boys fighting with serious grace; the warm figure of the **fisherman**, tanned by the sun moves with natural grace as he manages his catch. In the **fresco of the antelopes** the agile animals reveal the skill of the Minoan painters and their passion for scenes of daily life. In the **fresco of the naval expedition** a long scene with many characters portrays what was probably an historic event. The frescoes from Thira are evidence of the great seagoing supremacy of the Minoans and their outstanding artistic and expressive skills.

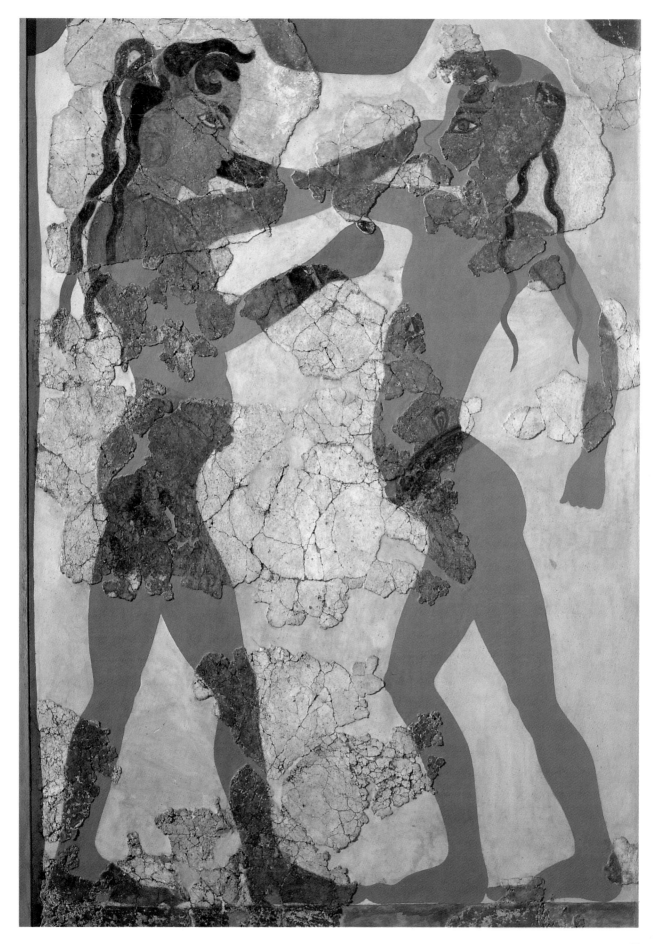

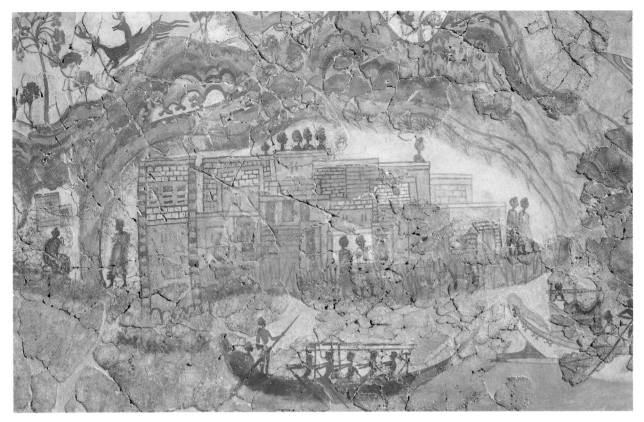

Detail of the naval expedition fresco.

The "Warrior Vase".

Female head (a sphinx?).

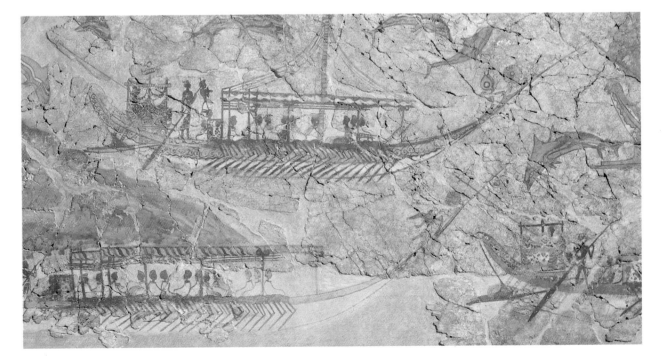

THE MYCENAEAN CIVILIZATION

Homer sang and immortalized the mythical expedition against Troy in his epic poems the Iliad and the Odyssey. When excavations were begun at Mycene in 1876, home of the legendary king Agamemnon who led the Greeks to victory against the Trojans, they brought to light a new prehistoric civilization, proving that Homer's heroes were not mere literary characters. Subsequently, research and studies on myths, mythological traditions and archeological finds led to the conclusion that the Indo-European people who settled on the Greek peninsula—and obviously Mycene—at the beginning of the second millenium B.C. were the first Greeks. For a thousand years a civilization with the same socio-economic structure, the same funeral rites and most important of all, the same writing, the "linear B", developed on various parts of the continent and also on the Greek islands. When this syllabic form of writing was

63

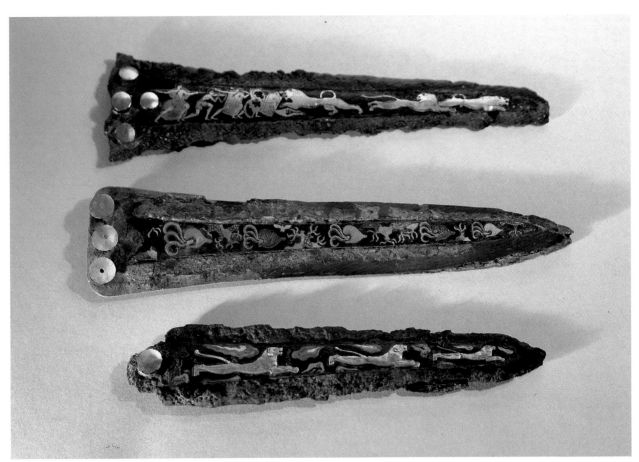

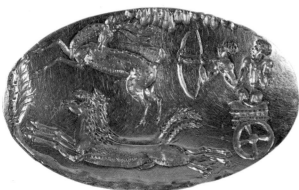

Bronze daggers with engraved decorations.

Gold signet rings.

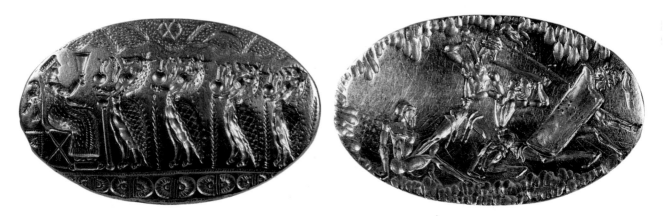

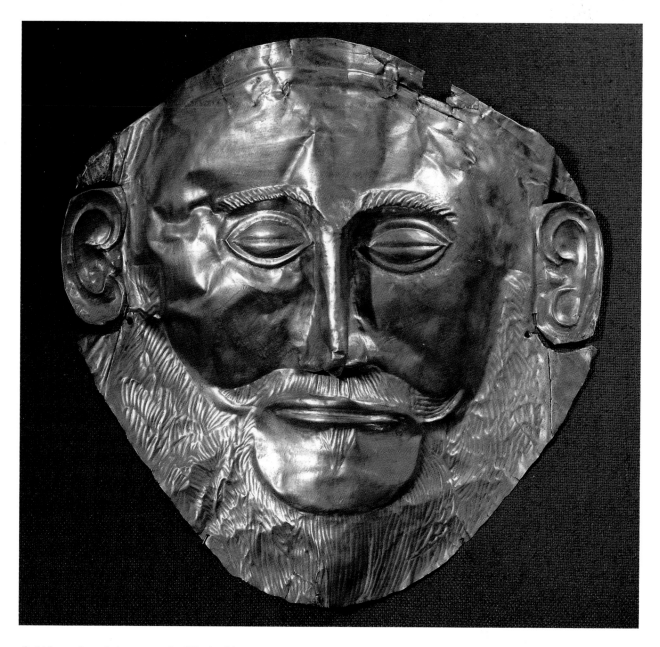

Gold funeral mask, known as the "Mask of Agamemnon".

deciphered it proved that the inhabitants of the region spoke Greek and therefore, the heroes of the Iliad and the Odyssey had really lived, and what is more, they were Greeks.

The "**Warrior Vase**", (1200 B.C., circa) the only extant example of Mycenaean vase painting depicting human figures was found on the acropolis of Mycene, fortified by cyclopean walls. Fully armed warriors depart for battle while on the right, a female figure bids them good-bye. The vigorous, virile Mycenaean concept of the world, is fully expressed in this piece. The **Sphinx head** (XIII century B.C.) was found in a house south of the Grave Circle of the acropolis. The sphinx or goddess can be found in this example of rare plasticity, with its multicolored sections, enigmatic expression and mysterious function. When, in 1876 Heinrich Schliemann discovered the royal tombs in the Grave Circle on the acropolis of Mycene, overcome by the

enthusiasm and euphoria of the moment, he thought that he had found **Agamemnon's golden funeral mask** in the fifth tomb. This Grave Circle, however, with its six tombs and nineteen bodies dates from the XVI century B.C., that is four centuries prior to the Trojan War. Therefore, the mask was not that of the legendary king who led the Greeks in their long battle against Troy and who was murdered by his wife Clytemnestra on the day of his return home. The impressive and majestic face of this gold mask reveals the unknown artist's attempt at realistically portraying the features of a Mycenaean sovereign. The valuable objects that were buried with the dead, such as jewels, weapons, and vases are testimony of the deceased's social position and of profound belief in an afterlife. The riches, the unsurpassable artistic skill, especially as seen in the small jewels and decorative motifs are evidence of a strong society, organized in a military fashion. But it was a society that

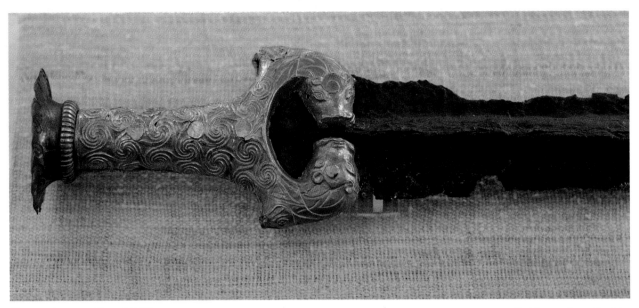

Bronze dagger with gold hilt.

Gold cups from Vaphio.

also lived a life, as we learn from Homer's lines, based on battles, hunting, religious rituals and symposia. The relief work on **bronze daggers** from the tombs at Mycene and Pylos are rendered more alive and natural by the gold and silver applied to the surfaces. Hunting scenes, sea creatures, and wild animals all move with strength, freshness and plasticity. Even the **signet-rings** can be considered masterpieces of goldsmithing. The largest, found at Tiryns portrays monsters with lion heads that offer a seated goddess libation cups, while others were engraved with the popular hunting scenes.

The royal tombs also yielded gold **necklaces** and **crowns**, **bronze swords** with gold-clad hilts, gold and silver vessels for sacred rites, golden bowls and so many other objects that make us understand Homer's description of "Mycene, the city rich in gold." The absolute masterpieces of Mycenaean goldsmithing, however, are the two **gold cups from Vaphio** (XV century B.C.) from the area near Sparta. The stupendous chased work depicts the capture of wild bulls with nets on one and a scene with cows on the other. The incomparable technique and artistic sensitivity that characterize these cups make them the finest examples of Mycenaean art and glory.

Golden tiara.

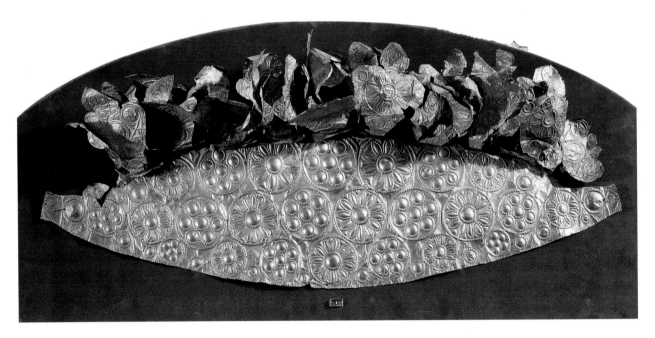

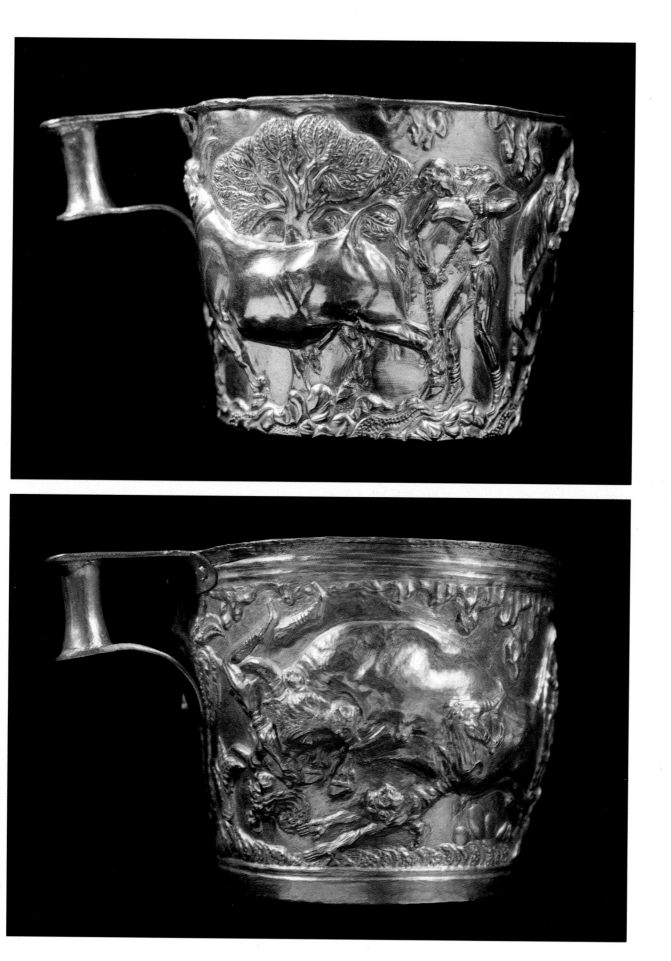

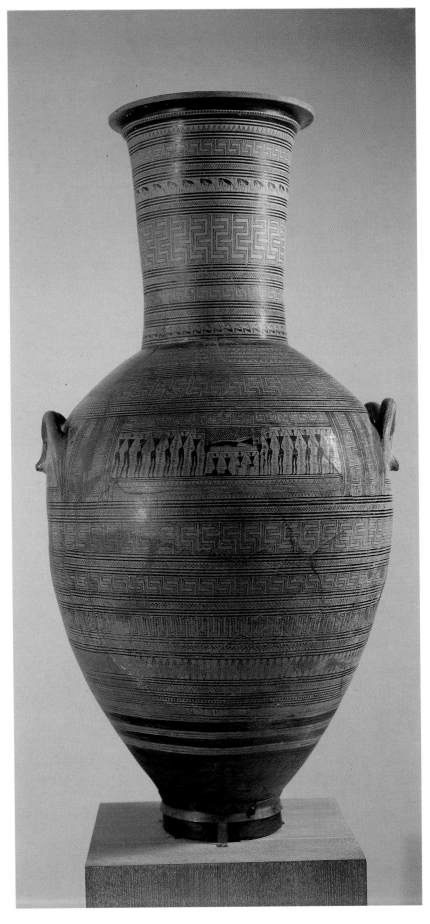

Geometric amphora from the Diplyon (750 B.C.). This is a magnificent example of a funerary object found in the ancient necropolis of the Athenian Keramikos. The vase is divided into horizontal bands decorated with geometric patterns and single or double meanders. The central band depicts the deceased on the bier. The elegance of the Attic clay harmonizes with the symmetry, precision and severity of this geometric expression of art.

The **Kouroi.** Greek sculpture was born around the middle of the VII century B.C. The male figure was represented by the strong, nude bodies known as *Kouroi*. Whether they were votive or funerary objects, whether they depicted gods or mortals, the Kouroi always stood in the same position, with the left leg slightly forward of the right, the arms stiff and held tightly to the body, long curly hair and an the lips gently curved in an Archaic smile. Their geometric composition, closely linked to frontality confers a feeling of "latent motion". The giant **Kouros from Sounion** (600 B.C.) was found near the temple of Poseidon at Sounion, and the **Kroisos** (520 B.C.) respectively define the era in which the body of the Kouros made the transition from the "heavy" figure, in the former to the artistic maturity of the latter. The Diplyon head (620 B.C.) is from a Kouros funeral monument found at the Diplyon. The oval face with the big slanted eyes and thick hair are an extraordinary expression of the internal vibrations present in this highly inspired statue.

Geometric amphora from the Diplyon.

The "Kouros from Sounion".

Kroisos.

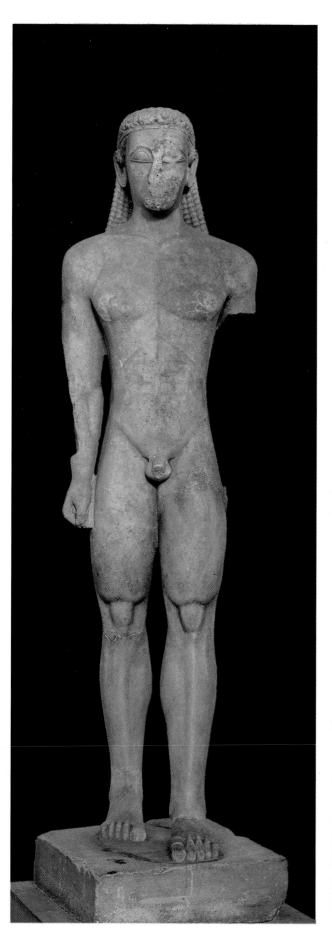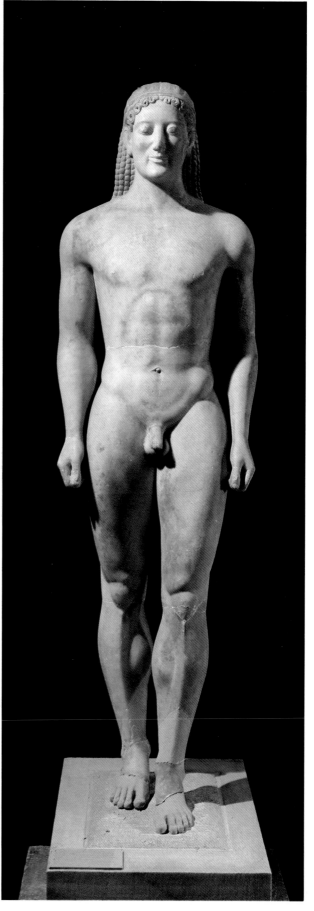

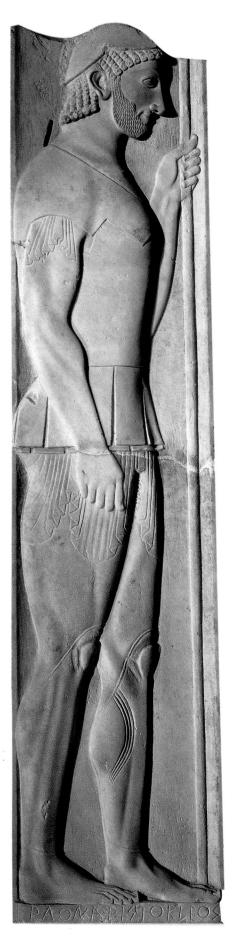

The **funeral stele of Artistion** (500 B.C.). signed by Aristokles as we can read from the inscription on the base portrays a hoplite with a light chiton, armor, jambe, helmet and spear. It is one of the best preserved ancient steles and one of the most perfect sculptures by this artist who has left us many other fine works.

The unusual **stele of the hoplite-runner** (500 B.C.) shows a young nude male, wearing only a helmet, in a running position. Carved with great care and elegance, the entire surface contributes to the development of the figure's position. Funerary steles from the Archaic and Classical period were put up as grave markers. They depicted the heroic figure of the deceased in relief, and have come down to us as evidence of the great value of Greek history and art.

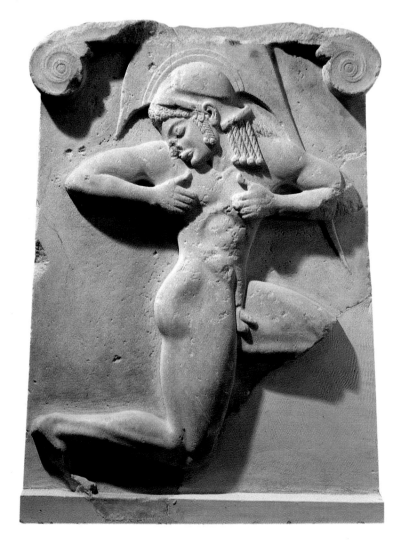

Acroterion from the temple of Asklepios
(380 B.C.). An entire room of the Museum
is dedicated to sculptures from the temple of
Asklepios at Epidauros. The female figure
on horseback, a Nereid or Aurasta is rising
from the sea. The horse, which fulfills its
decorative role is rearing on its hind legs,
the folds on the dress do not hide the strong,
young body.

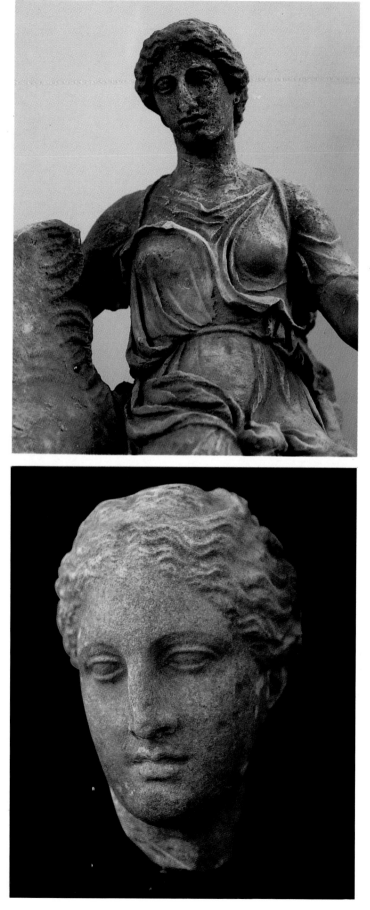

Head of Hygieia (Health, 360 B.C.). This
female head comes from the temple of
Athena Alea at Tegea in Arcadia. It was
probably part of a cult statue of Hygieia,
daughter of Asklepios, god of medicine. The
incomparable divine sweetness that
emanates from the statue is entirely in keep-
ing with the role of the goddess who allevi-
ated human suffering. The female beauty is
enhanced by a harmony that goes beyond
the earthly, concealing all the tenderness
and passion of the female nature.

71

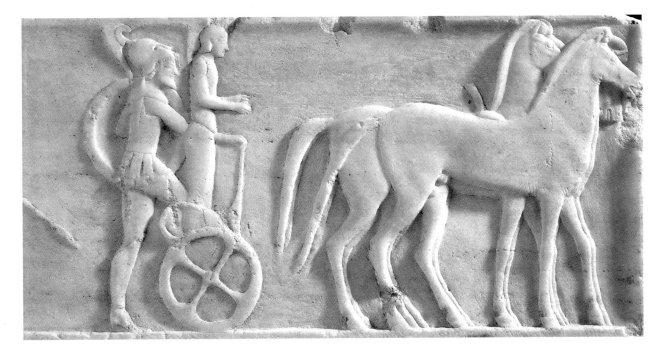

Base from the statue of a Kouros (n.3477, 490 B.C.). reliefs on three sides show a procession of chariots and hoplites.

The two bases were found in the wall of Themistocles that was built in 478 B.C. to protect Athens from another Persian attack.

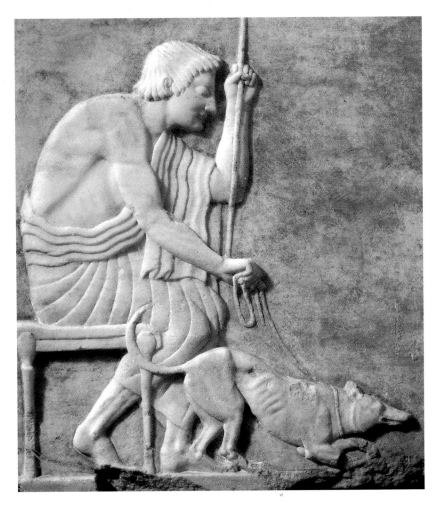

Square base of a statue of a Kouros (n.3476, 510 B.C.). with relief work on three sides depicting scenes from the life, training and relaxation of athletes.
In an extraordinary relief on a red ground, we can admire the graceful bodies of well-trained young athletes with luminous faces.

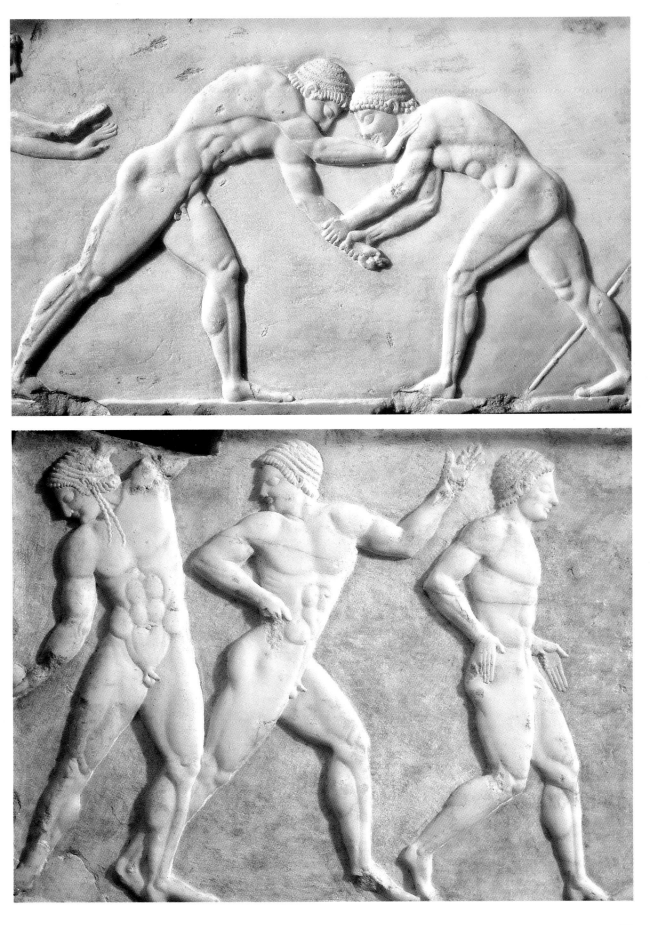

73

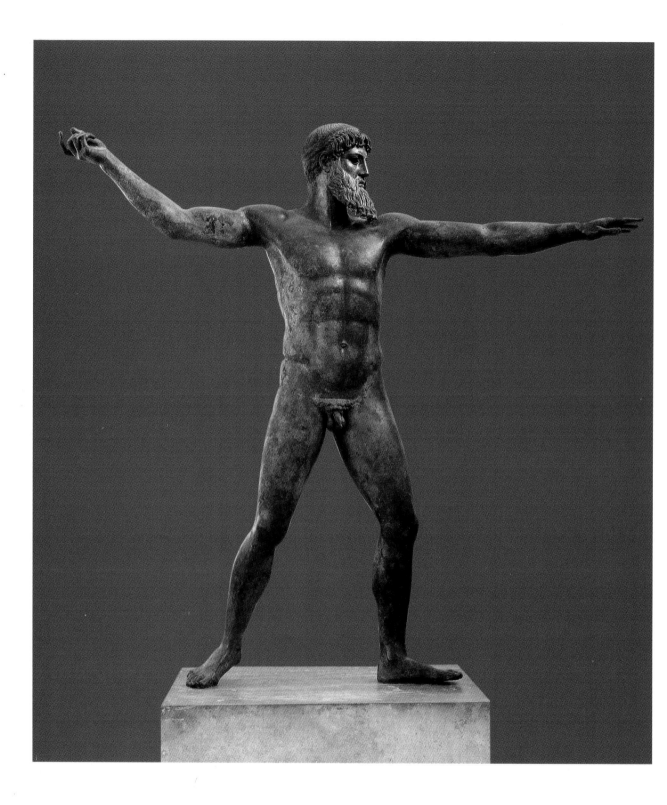

Poseidon from Cape Artemisium (460.B.C.). This powerful bronze statue was found underwater in 1928 not far from the Cape of Artemisium (North Euboea). It portrays Poseidon, god of the sea, poised to hurl the trident he holds in his right hand. Strong legs support the perfect, broad chested body and counter-balance the horizontal movement of the arms. But it is in the head (the eyes were originally set in) that the god's power and the artist's skill culminate. Powerful and calm, it emanates an aura of divine beauty, glory and grandeur. The god seems to be rising from the sea he governs, and he seems to dominate the earth that trembles when he causes an earthquake. The unsurpassable manner in which the artist (probably Kalamis) made this statue rendered him immortal. The god seems to be proud of his era, the grandiose moment at the beginning of the V century B.C.

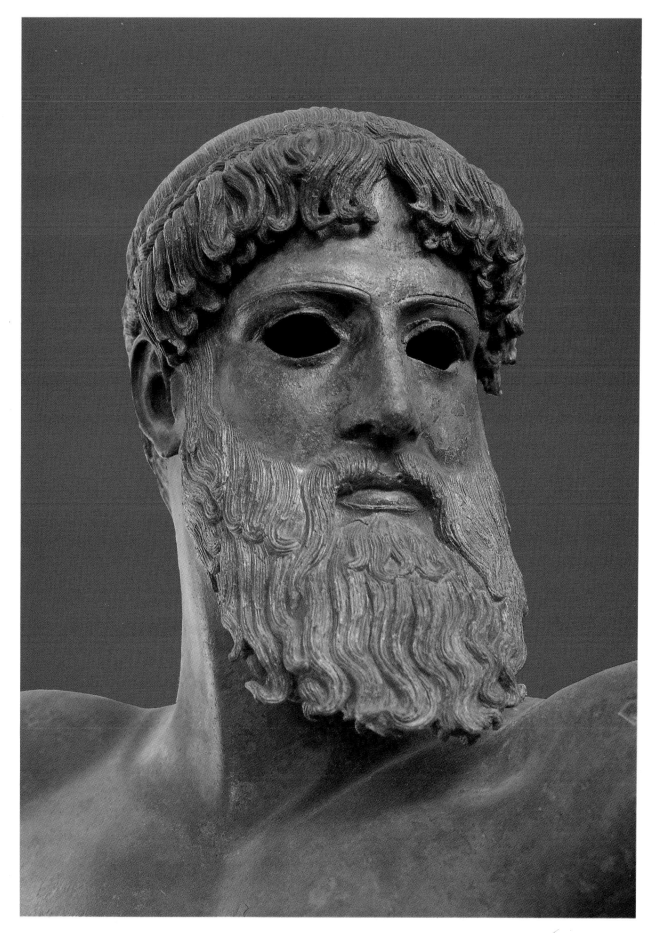

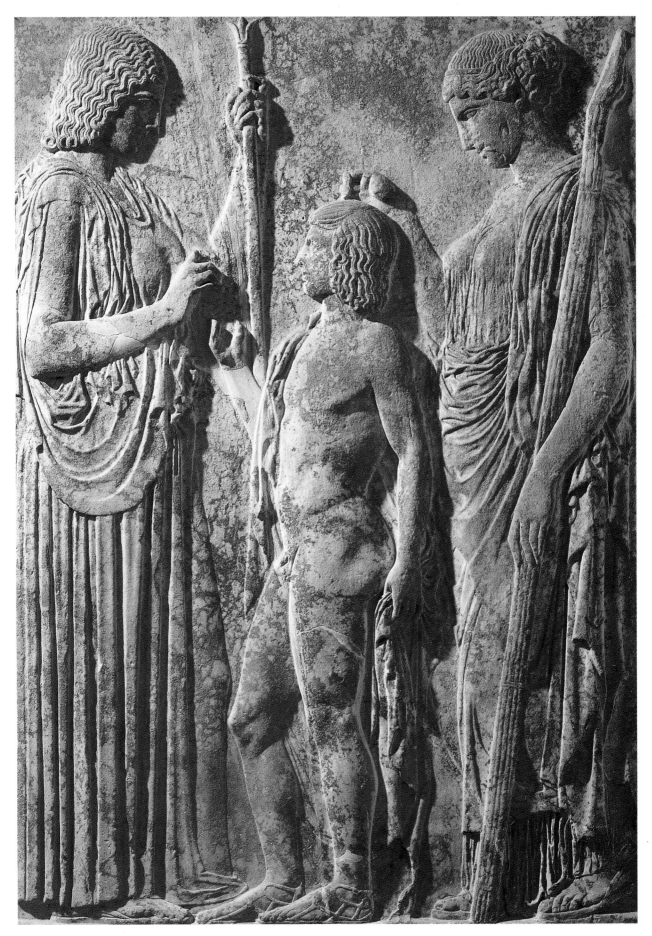

The Large relief from Eleusis (430-420 B.C.). This sculpture was found at Eleusis where the Eleusinian mysteries were celebrated every year. It depicts the goddess Demeter with a sceptre in hand as she gives sheaves of grain to the young Triptolemos who, in turn will give them to mankind. On the right, Persephone, blesses the youth. In this masterpiece that dates from the same period as the Parthenon, the Doric figure of Demeter coexists with the Ionic elements in Persephone, and together they emanate the mysterious religiosity that characterized the Eleusinian cult.

The Crowning (460 B.C., ca.). This is a votive stele with a relief sculpture found at Cape Sounion. The nude ephebus has a hand raised to place a metal crown on his head, probably in a competition. This is a splendid Attic sculpture in the "severe style".

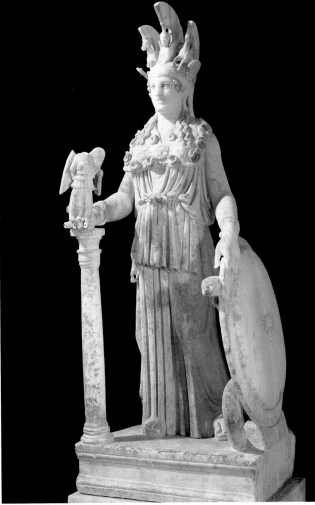

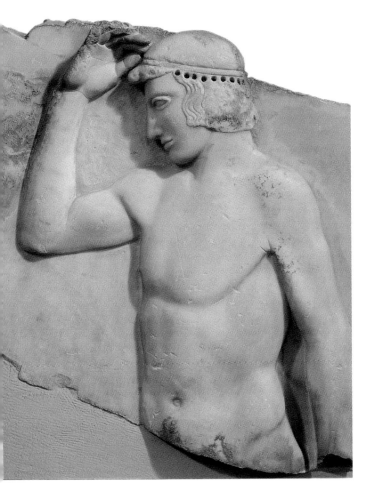

The Varvakeion Athena (II century B.C.). This statue of Athena the virgin is a reduced copy of the famous gold and ivory by Phidias that stood in the Parthenon for one thousand years. The goddess wears a peplos and a helmet decorated with Pegasus and sphinxes. Her armor is decorated with snakes and in her right hand she holds a small winged victory, while Errichthonius is curled up on her shield. This crude, cold statue lacks inspiration; it dates from the Roman period and is the only copy of the famous cult statue that stood in the Parthenon. It takes its name from the place in Athens where it was found.

Horse and Jockey of Artemisium (II century ▶ B.C.). This statue was found together with the bronze Poseidon in 1928 not far from Cape Artemisium. The question as to whether this small horse and rider were part of the same bronze group is still unanswered. The horse is racing at a full gallop while the young jockey, dressed in a short tunic, is holding on tightly to stay astride. Here Hellenistic artistic expression achieves "pathos" through the realism that characterizes the figures, their motion and the composition of the group.

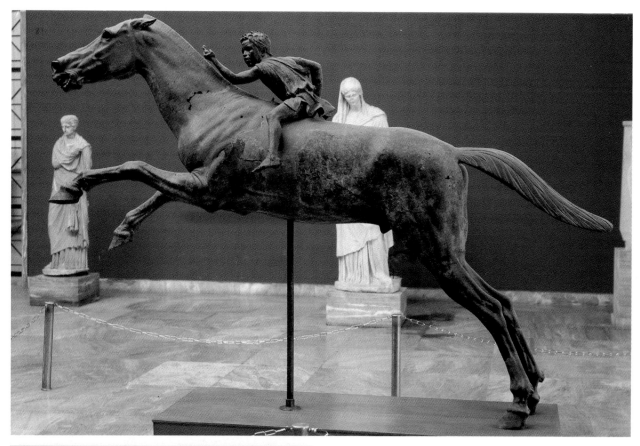

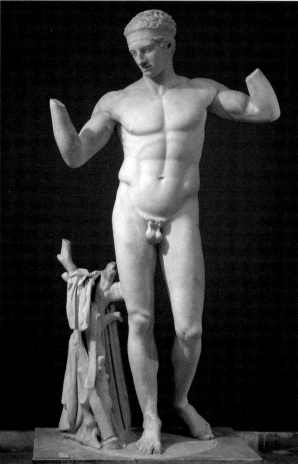

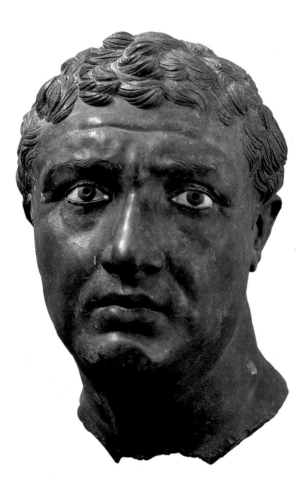

Diadumenos (I Century B.C.). This is a young man with a band around his head, one bent leg, the torso bent in the direction of the other, straight leg and arms raised. It was found on the Island of Delos. It is a good copy of a bronze statue by Polycleitos (430 B.C. circa) The famous sculptor, a native of Argos, brought new expression to the art of sculpting through the tension and relaxation of the legs, creating new rhythms and motion through new position.

Bronze Head (100 B.C. circa). This statue, found at Delos, is of a mature man whose head is bent by fatigue. His upturned gaze expresses anxiety, insecurity, anguish and doubt. There seems to be nostalgia for something lost, while the future seems to be void of hope. The statue is considered one of the finest examples of Hellenistic portraiture, as it expresses all the anxiety of man and his society.

Ephebus of Antikythera (340 B.C., circa). This bronze statue was found, along with other works, in 1900 in the wreck of a Roman ship at the bottom of the sea. It is of a youth standing on his left leg, with his right hand extended. The left hand and right leg are relaxed. The youth could well be Paris, whose judgement of the three goddess, and the apple of discord led to the Trojan War. The vigorous and well-positioned body fully expresses the spirit of the era. Harmony of movement combines with the ideal of the solid structure. This characterizes V Century B.C. art with the search for an art that is richer in its representations of the human form than that of IV century B.C. artistic movements.

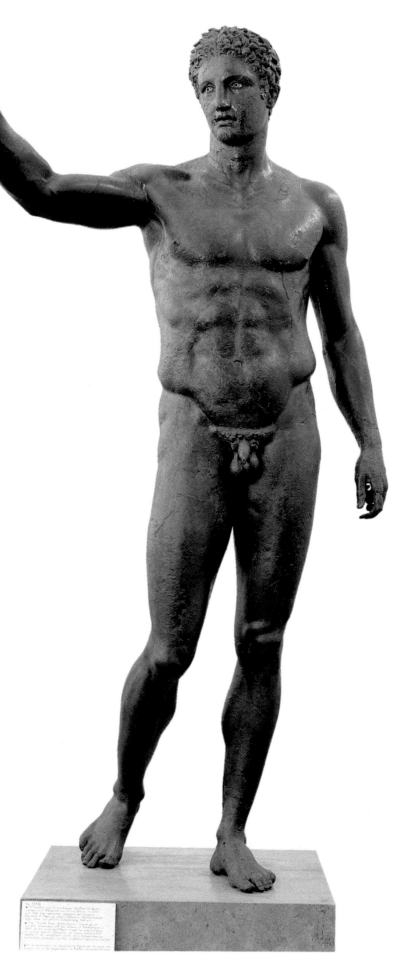

POTTERY

Architecture, sculpture and pottery were the three major fields of ancient Greek art. There is an extensive pottery collection in the Archeological Museum with items from all parts of Greece. During the historic period, thanks to the readily available clay and their high artistic level, Greek potters turned out true masterpieces. From the VI century the potters worked closely with the decorators to make exactly the right type of vase. The painted decorations were applied at various phases of the firing process. In the black-figured vases the scenes are painted onto red backgrounds and the details are etched in. Around 530 B.C. red-figured pottery made its debut in which the decoration was left in the original color and the background is filled in black, while details were rendered in thin black lines. Although this technique was more difficult and created greater problems, it was preferred by the Athenian painters. The vases were meant for daily or ceremonial-funerary uses with many decorative motifs. They are considered our richest source of information about mythology, military tactics, women's work and activities, agriculture and daily life in general. As pottery evolved, the compositions transformed adjusting to and following the shape and lines of each vase, highlighting and enhancing the decorative motif. The **red-figured amphora** shows two boxers binding leather straps around their hands, to strengthen their wrists. The **black figured oinochoe** depicts a feast with male figures gaily under the influence of Dionysiac wine. The **black-figured krater** found at Farsala portrays a scene from Homer's Iliad. Greeks and Trojans battle furiously around the body of Patrocles, Achilles' closest friend. In the Athens of the V century B.C. yet another method of decorating pottery developed. Polychrome designs were represented on a white ground. This new technique was used mainly on Lekythoi, sepulchral vases that were buried with the dead, that is why the motifs are usually related to funeral rites and death. The large **white lekythoi** shows the supreme moment of death, the profound solitude of the deceased with grieving relatives, submerged in the silence of deep mourning.

White lekythoi.

Red-figured amphora.

Black-figured onoichoe.

Detail of the black-figured krater from Farsala.

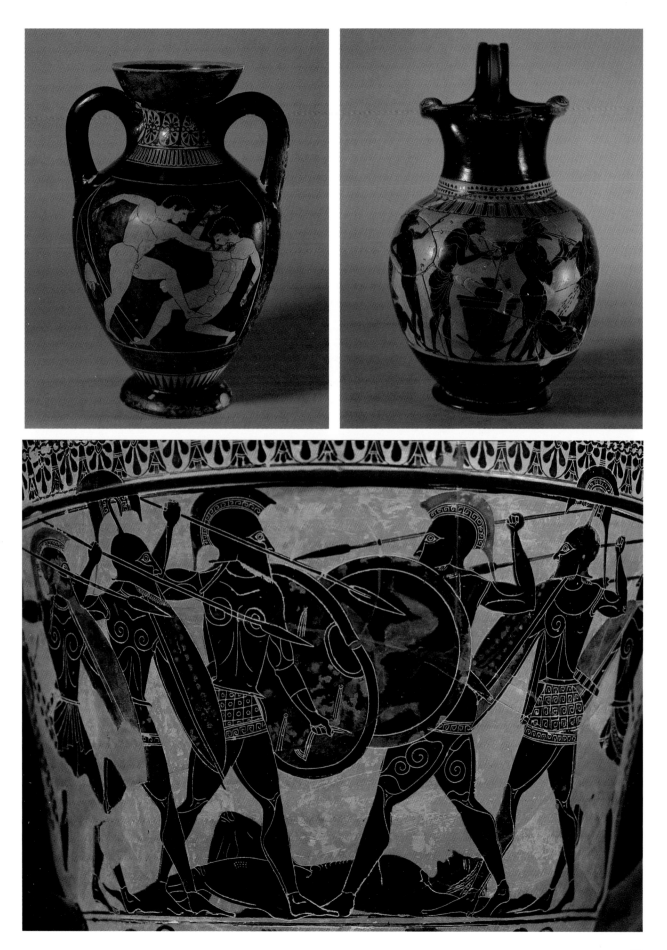

The church of St. Catherine in the Plaka.

The church of Panaghia Kapnikarea.

Aghia Varvàra (St. Barbara), icon from the chapel at
Kapnikarea.

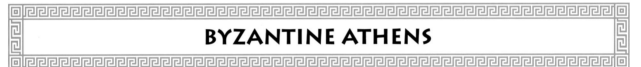

BYZANTINE ATHENS

The arrival of St. Paul, who in 51 A.D. preached the True God on the Areopagus, marked the beginning of the Christian era in Athenian history. A small congregation was established, led by the first bishop Dionysius The Areopagite. While Athens maintained its cultural splendor, helping the founders of the new religion, Constantinople, the city that was to become the political and cultural center of the Byzantine Empire and the entire Christian east was founded on the Bosphorus. In the VI century the transformation of Athenian temples into churches was complete and Justinian decreed the closing of the philosophical academies. This edict was responsible for changing the city from a large and flourishing center into a small, insignificant town. In the XI century when the Emperor Basil II liberated the Balkan peninsula by defeating the Bulgarian forces and celebrated his victory on the Acropolis at the Parthenon (which had already been transformed into a church in honor of Our Lady of Athens), a positive period began, marked by the construction of many monasteries both in the city and on its outskirts. It was a period that was to last until the end of the XII century.

Not many Byzantine churches remain in Athens today, but foreign visitors in the XVII century wrote about 100 or 200 churches. Since then many have been sacrificed for various reasons, including archeological excavations. Today, the remaining churches are architecturally similar, built in the shape of a Greek cross with a dome, and even if they are small, they reveal great harmony of shape. The most important Byzantine churches are the **Agii Theodori** (1050-1075) near Stadhiou Street; the **small cathedral** (XII century) near the Cathedral of Athens, the **church of the Holy Apostles** (XI century) near the Agora and the church of the Great St. Mary on Kidathenaion Street in the old Plaka district. Near the monument of Lysikrates stands the **church of St. Catherine** (XI century) full of esthetic rhythm in its decorative motifs. However it is in the church called **Kapnikarea** that one can see the culmination of all the esthetic values found in the Byzantine churches of Athens. Inside there are admirable frescoes (1942-1954) by the great painter, writer and poet, Fotis Kondoglou. The quiet of the interior does not disappoint the expectations that develop when viewing the outside.

82

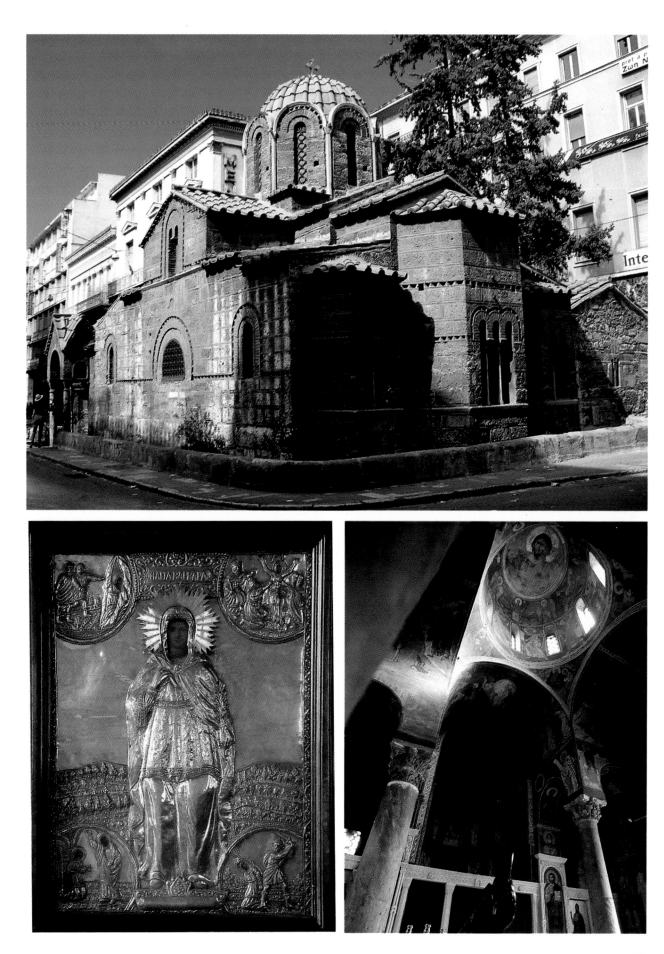

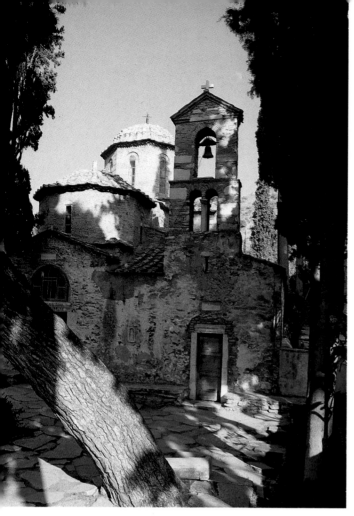

The church of the Virgin Mother of God in the Monastery of Kaisariani.

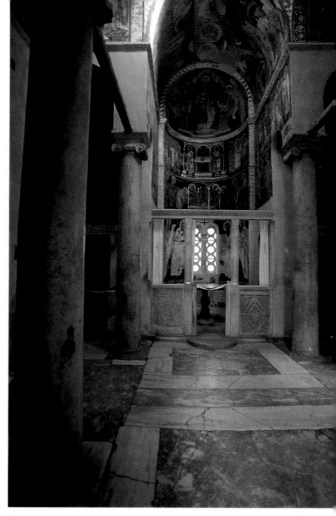

The interior of the church.

Christ Pantocrator in the dome of the main church.

The Holy Trinity on the dome of the narthex.

The cells.

THE MONASTERY OF KAISARIANI

Situated on the northern slope of Mount Hymettos, this monastery has maintained intact the morphology of the Byzantine monastery, that is the central church, the lateral naves, the refectory and the holy water font. In the middle of the cloister is the church of the **Virgin Mother of God** (XI century) with its agile proportions in the outside surfaces and the dome. The narthex and the small church dedicated to St. Anthony were added in the XVIII century with frescoes from the same period. The frescoes in the central church also date from the same period. The surrounding landscape is an eloquent expression of the peace that can be found in the Attic countryside. Ovid (43 B.C.-18 A.D.) sang the beauty of this place in his poems.

Reforestation and the creation of a botanical garden and experimental nurseries to collect and conserve various species of wildflowers, shrubs and trees was done by the Association of the Friends of the Athenian Woods.

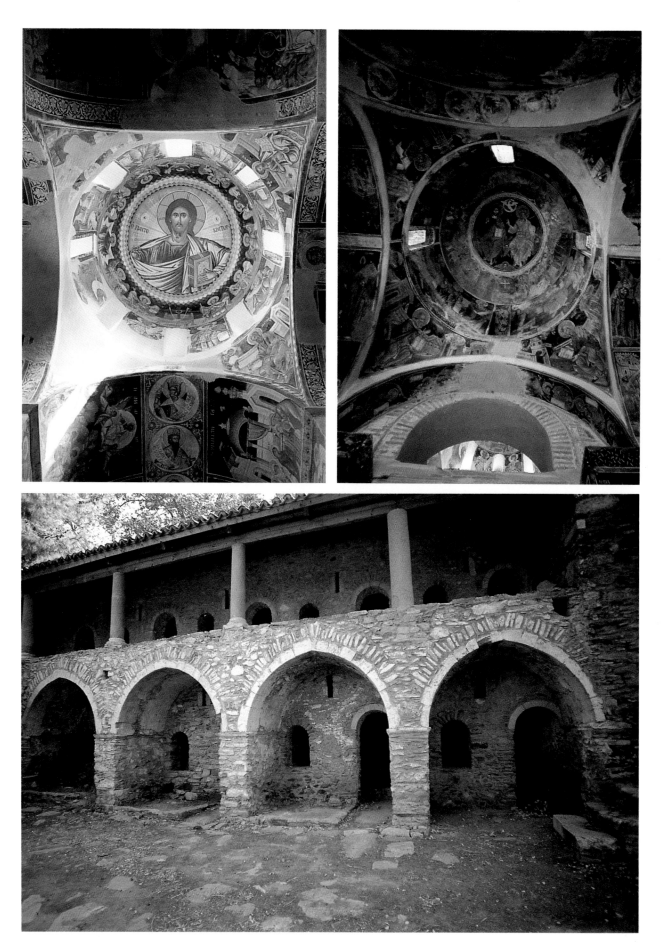

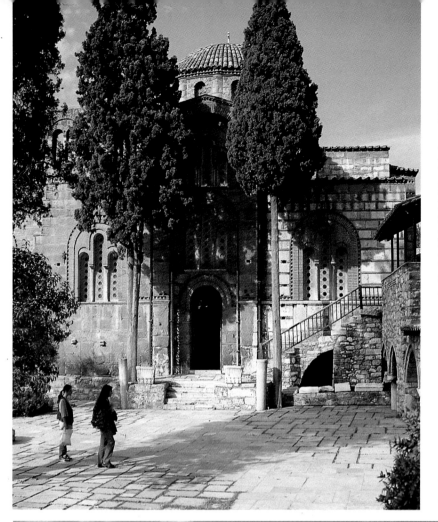

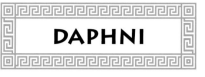

DAPHNI

About ten kilometers from Athens, towards the southwest on the way to Eleusis on what was once the Sacred Road rises the **Monastery of Daphni.** In all probability the Byzantine church was built around the end of the XI century on the site of a Paleochristian church which in turn had been erected over the ruins of an ancient sanctuary of Apollo surrounded by laurels.

The church of the Virgin at Daphni.

The courtyard of the monastery.

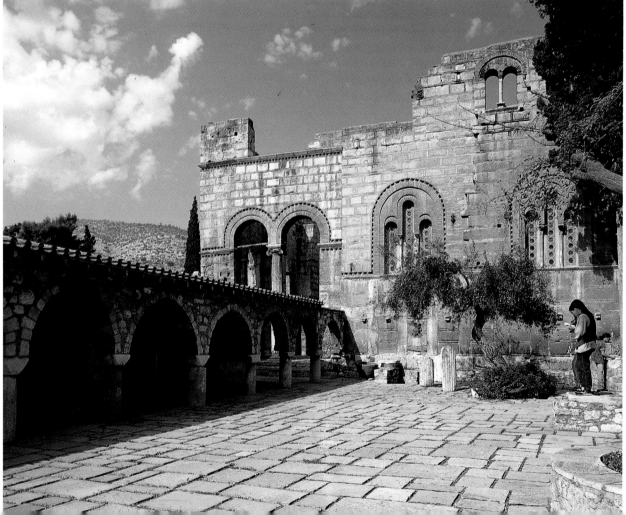

The birth of Christ.

Descent into Hades.

Unfortunately, the history of one of the most important remnants of Medieval Greek art is almost illegible.

The **church of the Virgin** is a work of art. The building, in accordance with the stylistic canons for the development of the volumes culminates in a dome over the central part. The dome is opened by windows that let light into the church enhancing the splendor of the mosaics depicting scenes from the life of Jesus and the Virgin. The gentle faces, that reflect the influence of ancient Greek art imbue the interior with peace and tranquility. Classical beauty can be seen transmitted to Medieval Greek art in a manner that reinforces faith and dedication to dogma. The Byzantine Empire did not deny its classical heritage, in fact, it conserved it and then passed it on to the West when the Turks conquered Constantinople in 1453.

The face of **Christ Pantocrator**, impartial judge of humanity, and lord of the universe is painted with a severity that is faithful to the canons. It symbolizes the independence and intellectual and cultural supremacy of Byzantium over the West in a critical period marked by political and spiritual

conflicts between the two worlds. The Schism between the Orthodox and Roman Catholic churches had already occurred (1054) and Byzantium was engaged with problems that led to the First Crusade (1096-1099). In spite of the major political rifts between the two sides, the Byzantine Renaissance was strong enough to influence Western art for two centuries (X to XII) as we can see from the mosaics in St. Mark's in Venice and in Palermo (Sicily).

Mosaics on the dome.

Detail of Christ Pantocrator on the dome.

The Annunciation of Joachim and Anne.

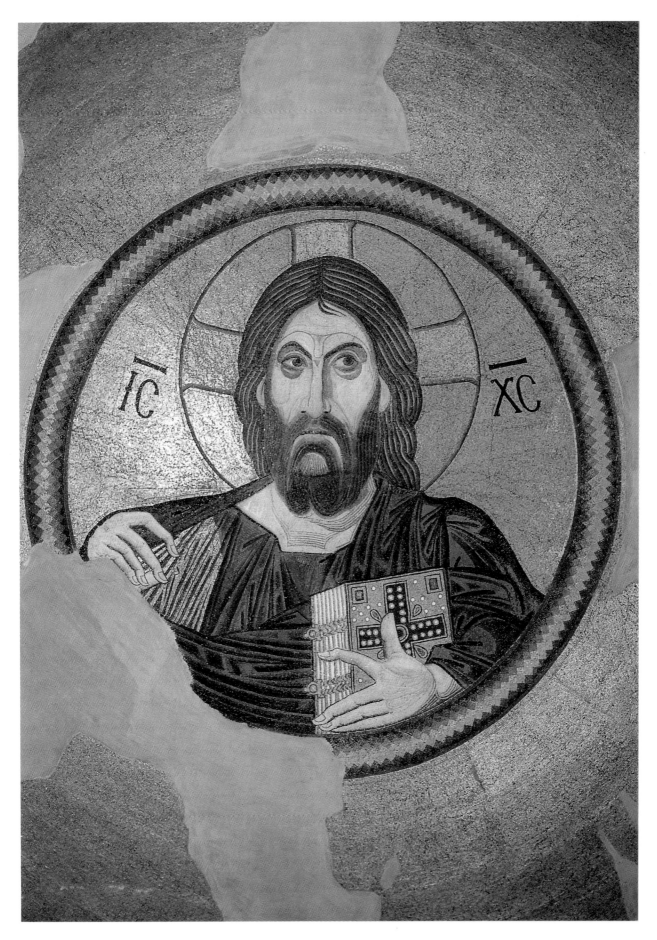

THE BYZANTINE MUSEUM

The Byzantine Museum of Athens was established in 1930 in order to acquaint the public with the treasures of early Christian and Medieval Greek civilization. It is located in a building designed by the architect Kleanthis in 1848 and was home to Sophie de Marbois, duchesse de Plaisance (1785-1854).

The Museum contains Paleochristian, Byzantine and Post-Byzantine works dating from the IV to the XIX centuries. From the dogmatic standpoint the early centuries of Christianity are characterized by the efforts to consolidate and strengthen the canons of the new religion, and in the visual arts this meant the creation of new thematic variations (IV-VII centuries). In the following centuries, the powerful Byzantine Empire, protector of the ancient Greek traditions and heritage isolated itself ideologically from the West. It became an important political, religious and cultural center, and a reference point for the entire East that was to last for over a thousand years. The conquest of Constantinople by the Ottomans in 1453, forced Orthodox Christianity into state of slavery, as it were, from which it was liberated in the XIX cent.

The museum room transformed into a an Early Christian Basilica with three naves.

The museum room transformed into a cruciform church with cupola.

The groundfloor rooms have been schematically transformed into places of worship where works from three major historical periods are displayed. In the room which is shaped like an **early Christian basilica with three naves** there are architectural sculptures, sarcophagi and inscriptions from the IV-VII centuries. The group portraying **Orpheus citharoedus** (circa 400) is from the transitional period between classical antiquity and Christianity. The second room, in the shape of a **cruciform church with a cupola** in the pure Byzantine style contains sculptures from the XI-XII centuries. The third room, a reproduction of a post-Byzantine church contains a tall iconostasis, a wooden chandelier and various sacred objects. On the second floor, the displays comprise Byzantine icons, frescoes, small objects, sacred items and priests' vestments from the post-Byzantine period and Coptic fabrics from regions where Greek civilization had its greatest influence. The most noteworthy items include the icon, carved in wood, portraying **Scenes from the life of St. George** (XII century) with a harmonious blend of the elements that characterized that troubled period in the history of the Byzantine Empire and western influences; the rare mosaic icon from Bithynia (Asia Minor) of the **Merciful Mother of God** which takes us into a very interesting period from the ideological and artistic standpoints, the era of the Paleologues. It is a piece in which theological thought encounters the skill of the artist who mas-

Orpheus playing the lyre.

Icon of Scenes from the Life of St. George.

The Crucifixion.

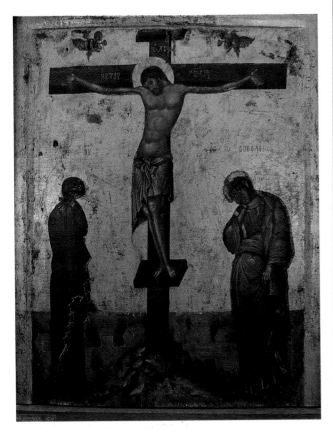

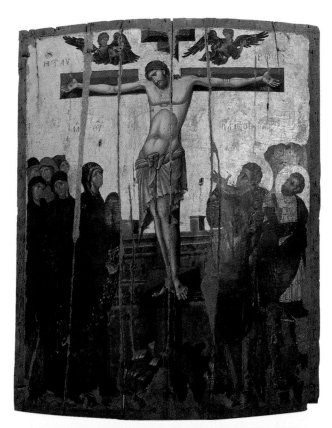

tered the hard materials of the mosaic tiles. Another important piece is the **Crucifixion of Christ** (XIV century) where the religious impact of the subject, the balanced design and use of color create one of the most significant and precious examples of art from Salonika in that period; the icon of the **Archangel Michael** from Constantinople is a rare work of classic beauty that reveals the refined artistic trends of the Byzantine capital during the reign of the Paleologues (1261-1453) when Hellenism was revived. The **Crucifixion** from the church of Monemvasia introduces us to the refinements of the second half of the XIV century. The Byzantine Museum offers the visitor a broad overview of developments in Byzantine and post-Byzantine art

The Crucifixion.

Icon of St. Marina.

Mosaic icon of the Merciful Mother of God.

Wooden iconostasis with an icon of the Virgin and St. Matthew.

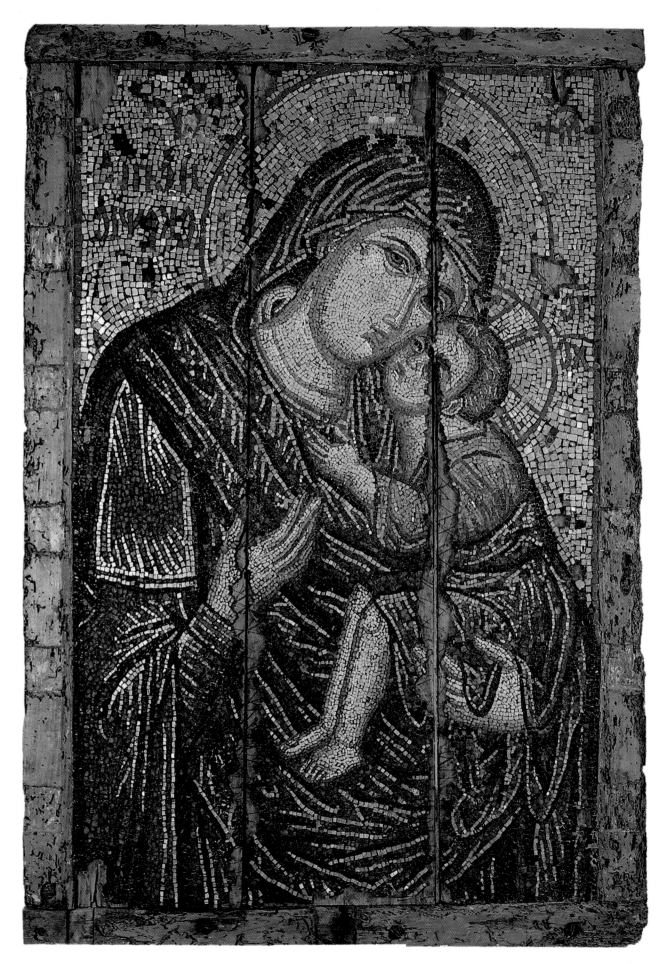

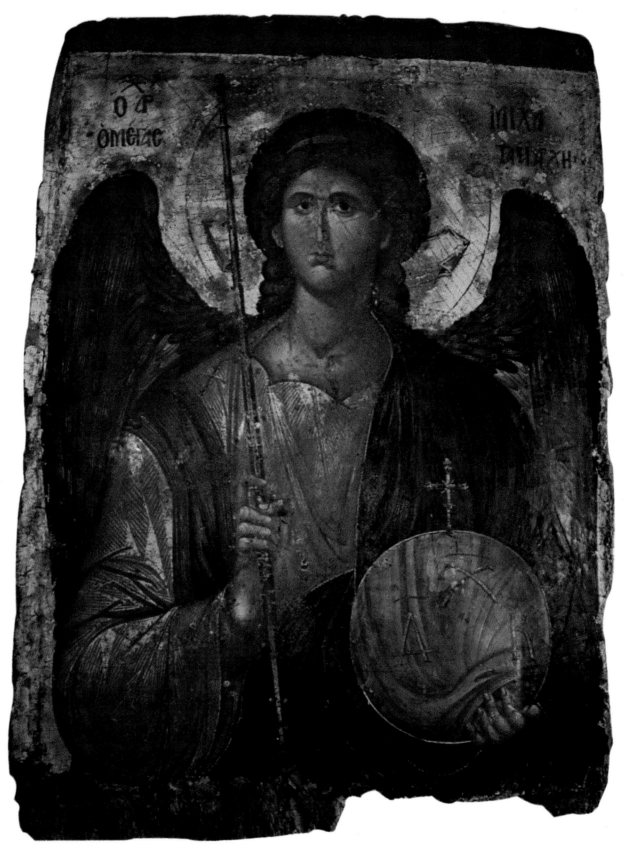

Icon with the Archangel Michael.

A room in the Byzantine Museum with detached frescoes, and the Dormition of the Virgin, a detached fresco.

over the centuries. Items such as the icon of **St. Marina** (XV century) or the **detached frescoes** (XIII-XVIII century), the small art objects, jewels, coins, pottery, church items from the XVIII century, Coptic fabrics from the V-VII centuries, the fabrics and paraments of the XVI and XVII centuries, respectively are all evidence of the lively activity that characterized this long period in Greek history.

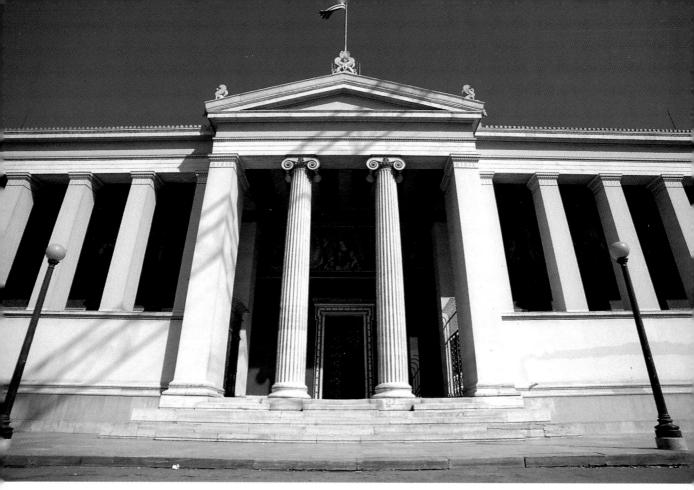

Façade of the University.

The Academy and the National Library.

THE NEOCLASSICAL BUILDINGS

When Athens was declared capital of the new Greek nation in 1834, Greek and European architects were assigned to redesign the city. The Romantic ideas of Classicism that were fashionable throughout Europe, the results of studies about ancient Greece and heightened activity in the field of archeology, found fertile ground here. It was natural for the first buildings erected along the new avenues to follow the style that faithfully and harmoniously reproduced the elements of classical architecture.

The **University**, designed by the Danish architect Christian Hansen was begun in 1839 and completed in 1864.

To its right stands the **Academy**, a gift of Simon Sinas, built between 1859 and 1885 to plans by another Danish architect, Theophile von Hansen and under the supervision of Ernst Ziller. The sculptures were carved by Leonidas Drosos. On two columns which reveal the beauty of the Ionic style there are statues of Athena and Apollo, while the two statues on the steps portray Aristotle and Plato. The two architects also worked on the **National Library** that was built after 1887 thanks to the donations by Panaghiotis Vallianos, whose statue stands at the entrance. The Library contains one of the most important collections of Greek manuscripts from as early as the VI century. The **Zappion** was also inspired by the same neoclassical principles; this building dominates the park with the same name. It was completed in 1888 thanks to donations by two cousins from Northern Epirus, Evanghelos and Costantinos Zappas. It was designed by the French architect F. Boulanger and was later modified by Theophile Hansen; today it is used for important public events. In the immediate vicinity stands the **Panathenian Stadium**. It was here that the ancient games were played. It was restored in Pentelic marble for the 1896 Olympiads, thanks to donations by Gheorghios Averof, born in Alexandria. The stadium has a seating capacity of 60,000 and hosts many important events. Behind the Zappion, on the western side of the National Gardens stands the impressive Royal Palace, a neo-classical building dated 1840 and seat of the Greek Parliament since 1935. Opposite the **Parliament**, facing the lively Constitution Square stands the **Monument to the Unknown Soldier**, with its continuous Presidential Guard, the famous **Euzons**.

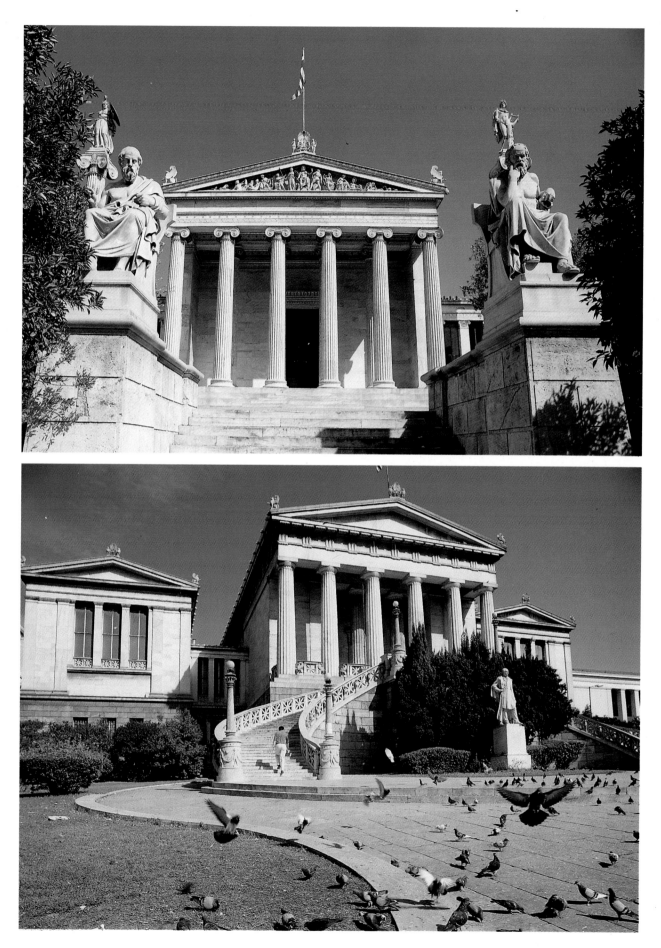

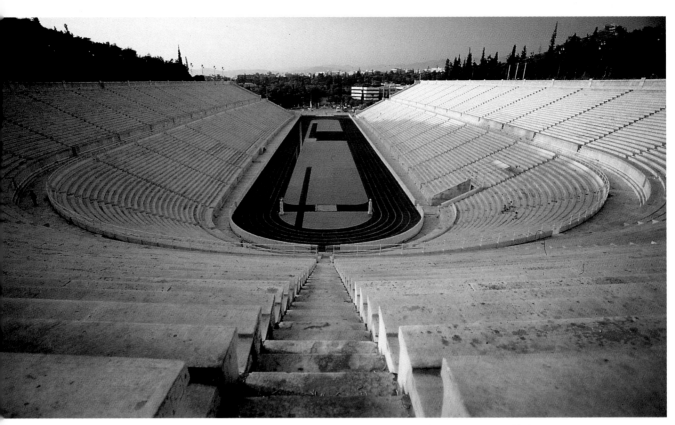

The Panathenian Stadium.

The Zappion

The "Euzons", the presidential guard at the Monument to of the Unknown Soldier, in front of the Parliament Building, Syntagma Square.

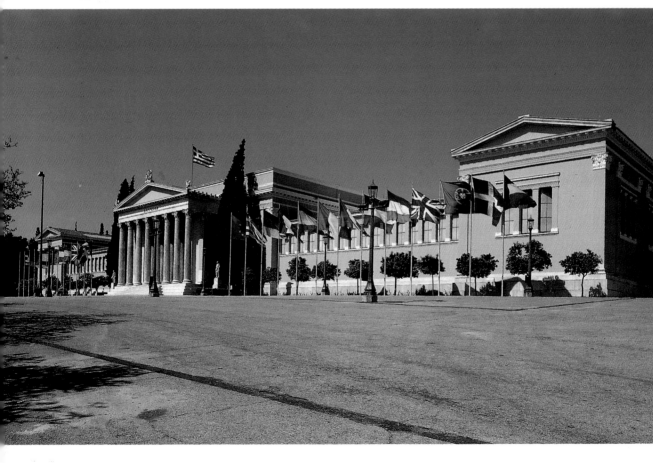

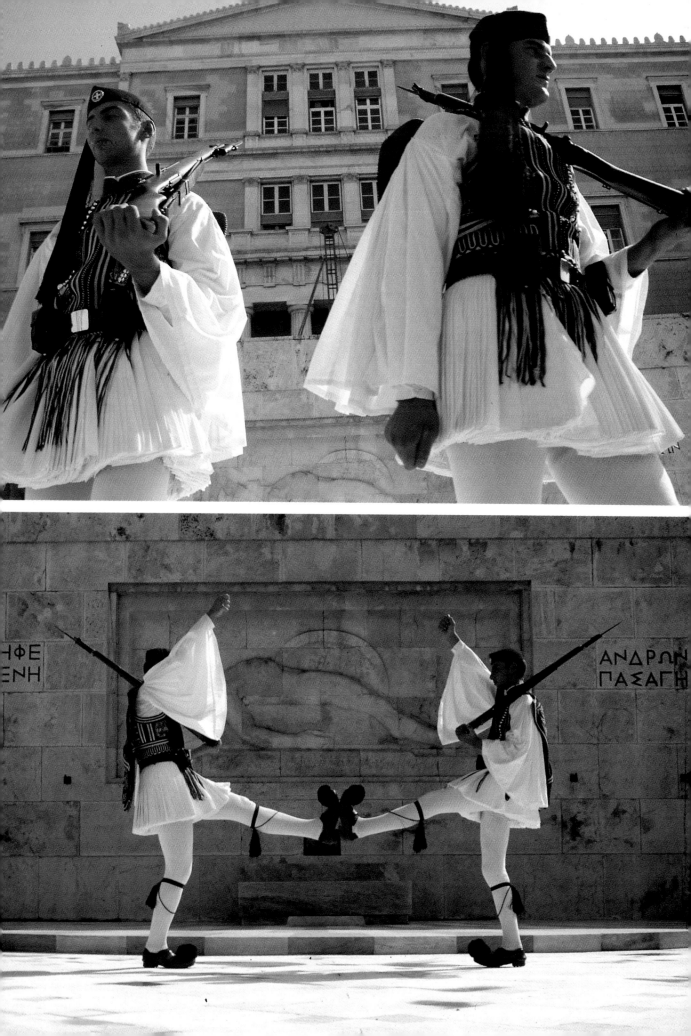

Neoclassical buildings in the Plaka. *Typical, picturesque scenes in the Plaka.*

THE PLAKA

The Plaka extends from the foot of the Acropolis, from east to north. It is a very picturesque district that reveals how the ancient residential section of Athens developed. It is characterized by ancient Greek, Christian and Islamic monuments. Since 1834 the new capital of the young Greek nation had been inhabited over the foundations of its distant past. It was here in 1837 that the first University was built, that the first noble or luxury homes were built and where the heart of its business and trading center continued to beat. Most of the neoclassical buildings in the Plaka district were erected after 1865; this fact contributed to the development of that typical neoclassical atmosphere that has made it famous. Since 1975, thanks to decisive action on the part of the government with decrees that protected the urban fabric, visitors can stroll through the narrow, picturesque streets and observe the city's history practically first hand. Starting from the ruins of ancient buildings, passing by the Byzantine churches and Turkish buildings, stopping in front of the neoclassical homes, up to the modern shops and typical nooks and crannies: that coexist in harmony filled with delightful surprises.

Just beyond the boundaries of the Plaka district, filled with modern buildings, rises the majestic **Athens Cathedral**, built in 1862. Next to it stands the **Small Cathedral**, a XII church that discreetly recalls the strong link with the Byzantine past. At **Monsastiraki** a small neighborhood in the Plaka, the traditional "Yioussurum" flea market is held every Sunday. The modern city, however, is just a few minutes' walk from this old, picturesque business center. The open space of **Constitution Square**, named after the first Greek Constitution of 1834, hosts many different social, activities; it is a meeting point for visitors and Athenians alike. Near the square stands the **Palace of Troy** (Iliu Melathron) home of Heinrich Schliemann, the German archeologist who uncovered the Mycenaean civilization. The Renaissance style building was designed by Ernst Ziller.

The "Yiossurum" flea market at Monastiraki, with the Tzistarakis Mosque (1759).

Schliemann's house (also known as the Palace of Troy) on Venizelos Street.

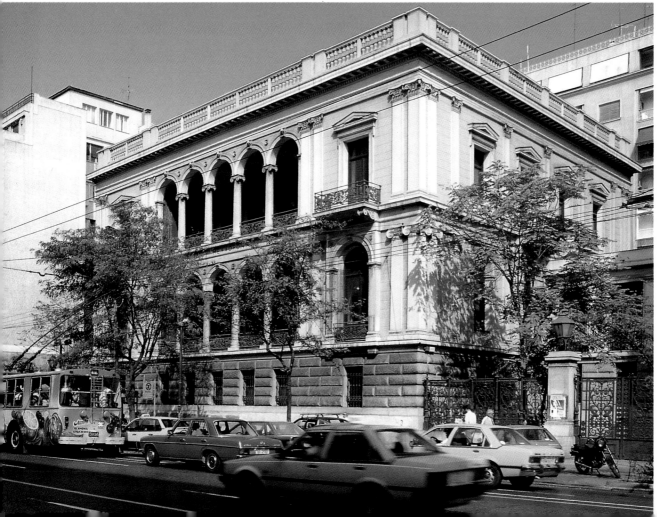

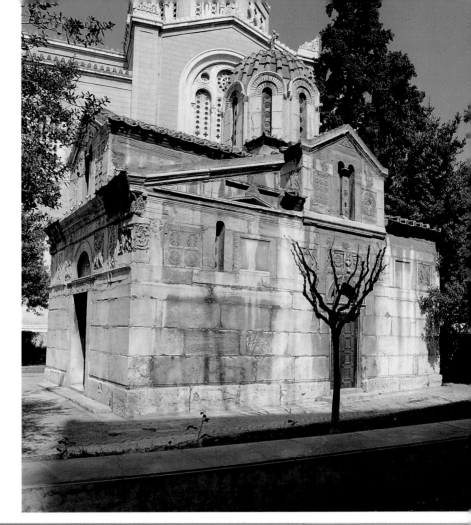

The Cathedrals of Athens.

The Birth of the Virgin.

Gold bracelets with lions' heads.

Since 1972 a neoclassical building situated on the north side of the Acropolis in the Plaka district has been home to the Paul and Alexandra Kanellopoulos collection which they donated to the government that year. The collection covers every period in Greek art. The prehistoric period is represented by Cycladian and Geometric vases and idols, Minoan and Mycenaean objects, Phoenician and Cyprian vases. The historic period - Archaic, Classical, Hellenistic and Roman - is represented by a large number of items such as jewels, vases, pottery idols, bronze figurines and coins. The museum also has a large collection of icons, liturgical, everyday items, jewels, crosses and coins dating from the early Christian era to our day.

Some of the exceptional pieces are the **gold bracelets with lions' heads** (IV century B.C.), and earrings with Cupids from the Hellenistic period. The finest of metals highlights the great technical skill of the Greek goldsmiths This art moved in parallel with the others, creating fine, precious jewels that adorned the bodies of the dead on the journeys into the afterworld. Some defensive weapons such as the Chalcidian style Archaic bronze helmet sometimes became votive objects in the sanctuaries or booty carried off the conquerors. The perfectly preserved black-figured Attic hydria (510 B.C.) depicts a famous Archaic fountain in the Ancient Agora, this was the famous "fountain of the nine springs" that was greatly admired in antiquity and today one is astounded by the decorative technique used on the vase. Femininity is portrayed with incomparable grace, elegance and tenderness in the terracotta female figurines of the "Tanagras" (II century B.C.). The excellent painting in the icon of the **Dormition of the Virgin** (late XIV century) transmits profound grief and religious respect. Finally, the **Birth of the Virgin** (early XVI century) is distinguished by the natural and human atmosphere that pervades the scene.

The Dormition of the Virgin.

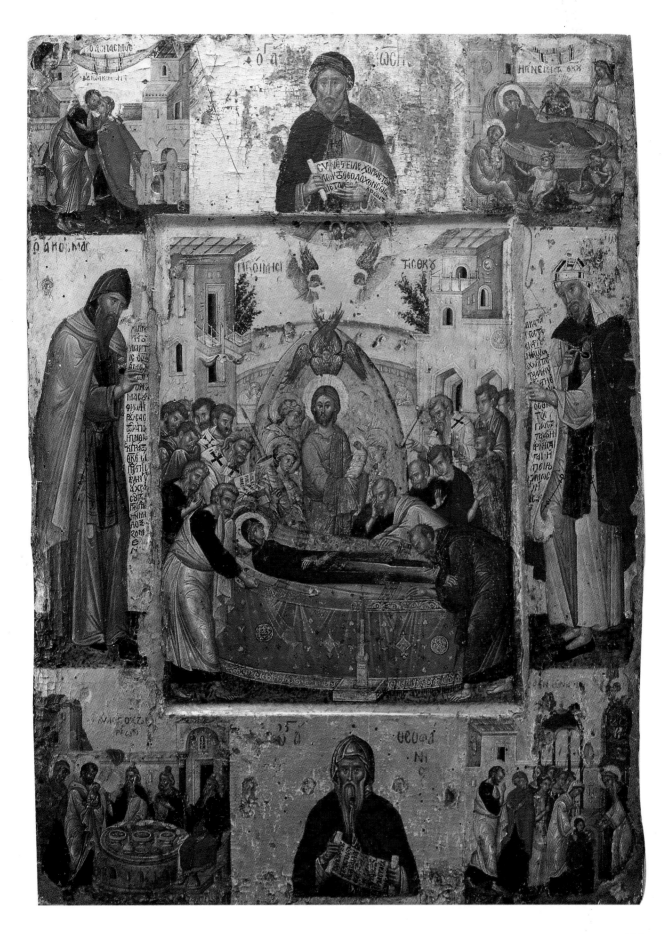

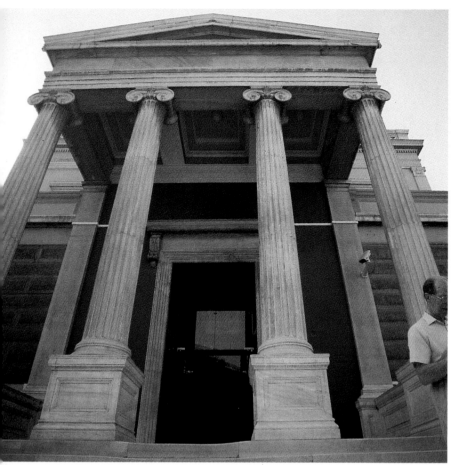

Since 1960, the National Historical Museum has been located on the ground floor of the old Parliament. The neoclassical building, designed by the French architect F. Boulanger was erected in 1858 and was the seat of the Greek Parliament from 1875 to 1935. The rooms surrounding the large Assembly Room contain a chronological exhibit of the most significant and representative items from Greek history, dating from 1453, the year Constantinople fell, to the threshold of the XX century. The items are part of the collections of the Greek Historical and Ethnological Association which also has a fine collection of documents and manuscripts, a large library and a photographic archive. Some of the most inter-

The entrance to the Museum, traditional costumes and flags.

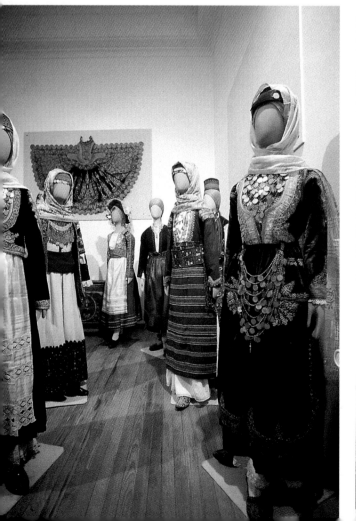

Two rooms in the Museum with weapons, mementoes and portraits of the heroes of the War of Independence.

esting items on display include mementoes of the French and Venetian dominations, such as helmets and armor, engravings of castles and famous battles; banners and standards and war booty from the Greek Revolution against the Turks, from the Cretan revolt against the Ottomans and the Balkan Wars, as well as a large number of weapons, medals, decorations, seals, souvenirs, personal objects and portraits of historical, political and military figures, intellectuals, church leaders and Philhellenes. There are also oil paintings, watercolors, drawings, engravings, maps, and many photographs of moments in Greek history in recent decades. Finally, there are also figureheads, cannons, ship logs, and navigational instruments from ships dating from the Revolt against the Ottoman Empire (1821); there is also a rich collection of uniforms and clothing from various regions and household items as well.

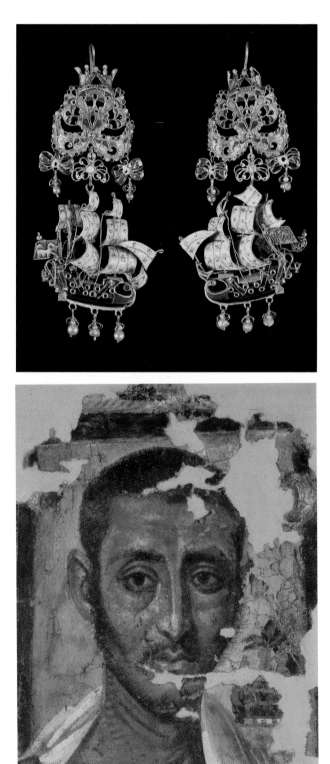

This museum was established by Antonios Benakis in 1930; a Greek born in Alexandria. It is located in a lovely neoclassical building that had been his family's home. Here Antonios Benakis arranged his historical and art collections and donated them to his country. The museum now contains five other donated collections, and is considered one of the finest since the items on display are distinguished by their rarity, as well as their historic and artistic value. From the historical standpoint these collections can be divided into three major periods. The period dedicated to Greek art from prehistory to the present is dominated by ancient Greek jewels, Protochristian, Byzantine and Post-Byzantine painting and examples of the "minor arts".

The Neo-Greek period, which accounts for most of the Museum includes Greek folk art from other countries, historical archives, mementoes from recent periods and priceless documents relative to European Philhellenism engravings, drawings and watercolors depicting ancient and recent Greek history, Greek landscapes and moments in everyday life that inspired visiting foreign painters from the XVI to XIX century. Yet another section comprises collections of local and domestic crafts, and miniatures from a large part of the Eastern Mediterranean region and inland, with interesting items of Greek, Islamic and European art. These three interdependent sectors illustrate the continuity of Greek art throughout Greece proper and the areas influenced by her civilization.

Golden earrings from Syphnos.

Portrait of a dead man.

Gold vases from Euboea.

The visitor can clearly see the close ties that unite the folk art of neighboring peoples and their reciprocal influences on the inspiration, techniques and traditions that these people share and which serve as a bridge between East and West. Just to give an idea of the scope of this museum, we can mention a few significant items from each major period: two unique **gold vases from the island of Euboea**, (3000 B.C.); the **portrait of a dead man** (III century A.D.) found at Faium (Egypt) one of the most typical paintings using the technique of pouring wax onto linen; an icon of the **Adoration of the Magi** (1565) by the great painter Domenikos Theotokopoulos (El Greco) from when he was still painting icons on the island of Crete; a gilded and enamelled **silver censer** in the shape of a Byzantine church with a cupola (1613); a fragment of a mosaic (IX century) depicting the Virgin from the Stoudio monastery (now destroyed) in Constantinople, and finally, **golden earrings from Syphnos** (XVIII century) in the shape of a caravel, with different colored enamels and pearls, of clear Venetian inspiration.

Domenikos Theotokopoulos (El Greco): Adoration of the Magi.

Gilded and enamelled silver censer.

N. Chadjikyriakos-Ghikas: The Studio.

N. Lytras: The Kiss.

THE NATIONAL GALLERY OF GREECE AND THE SOUTZOU MUSEUM

Ever since the founding of the new Greek state in 1834 there had been plans to open a museum of the visual arts. In 1900 Alexandros Soutzou donated his entire fortune to collect artworks and establish the National Gallery which was restructured in 1976. The original collection, created to promote knowledge of modern Greek art, was enriched by contributions from Greeks around the world, artists and collectors.

Since 1977, when the E. Kutlidis collection was acquired, one can say that XIX century Greek art is well represented. Currently, the Gallery organizes exhibitions and events and is an important cultural center of the capital.

After the XVI century, Neo-Hellenistic painting developed along several lines: moving from the religious to popular motifs to academic European romanticism, the Munich school and Impressionistic landscapes.

N. Ghyzis: The Engagement.

Since 1900 avant-garde artists gave an original imprint to modern Greek art which is distinguished by its intense Greek nature and the successful reinterpretation of the autochthonous tradition.

El Greco: Concert of Angels.

Hübsch: *View of Athens from the West* (1822), engraving by Schilbach.

A room containing furniture that belonged to Queen Amalia. On the wall, Edward Lear's painting "The Acropolis Seen from the West" (1852).

VOUROU-EUTAXIA MUSEUM
(MUSEUM OF THE CITY OF ATHENS)

The museum was founded in 1973 by L. Eutaxia and was opened to the public in 1980. It is housed in the home of S. Dekozis Vourou which was built in 1834 and used as the royal residence by the first sovereigns until 1843. The purpose of the museum is to provide knowledge about the history of Athens from the Frankish period on and to protect the respective artworks. The collections include several engravings and pictures of Athens done between the eighteenth and the early twentieth century; panels and sculptures of the city from the thirteenth to eighteenth centuries; furnishings and personal effects of Otho and Amalia, the first royal couple; the scale model of Athens in 1842 and twentieth century Greek paintings on subjects inspired by Athens.

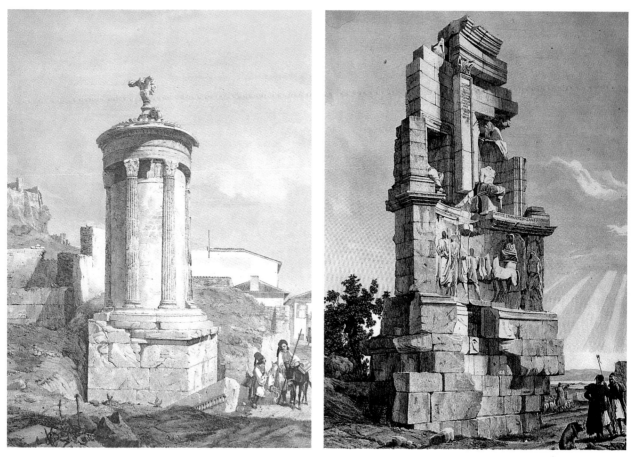

Two colored engravings by Andrea Gasparini: the monument of Lysikratos and the monument of Philopappos (1843).

Anonymous: View of Athens with the Acropolis and the Theseum (watercolor, 1830-40?).

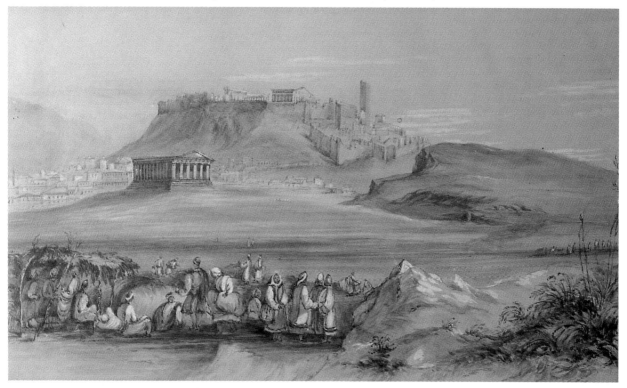

Large terracotta plate or "the pigeons' vase".

The Museum of Cycladian Art was established to house the priceless collection of N. and D. Goulandris. The displays are arranged so as to satisfy current concepts of a museum's role and purpose. On the first floor there are archeological finds from the Cycladian islands from the III millenium B.C.. Idols and vases made of Cycladian marble are striking in their simplicity and purity of line. On the second floor are the funerary objects and miscellaneous small items dating from 2000 B.C. to the IV Century B.C. As special exhibit has been arranged for the vases and jewels from the island of Skyros (1000-700 B.C.). There is also an admirable group of black-and red-figured vases, signed and unsigned by famous and unknown artists that provide an excellent overview of Archaic, Classical and Hellenistic art. All the pieces in the collection trace the development of Greek art and enrich our knowledge of the daily lives, and the religious, practical and esthetic concepts of the ancient Greeks.

Seated idol.

Female idol.

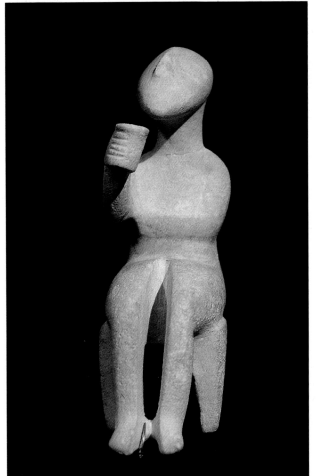

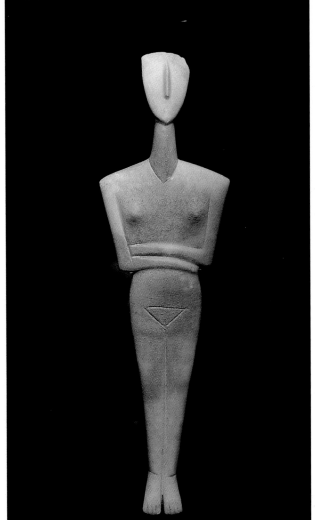

THE MUSEUM OF GREEK FOLK ART

Greek folk art flourished primarily in the latter period of the Turkish occupation, that is from the late XVII to the early XIX century. Due to its geographic position the country was subjected to two major influences. The first which was renewed with the Turkish occupation and another from the West which came with the French occupation and was stronger on the islands. These two, highly distinct modes of thought, contributed to the development of the distinguishing trait of Greek art without breaking its ties with tradition. The Greeks had the creative strength and the ability to absorb the foreign influences that were closest to their idiosyncratic ethnicity, and to transform them into works of a pure national style. The Museum of Greek Folk Art, located in the Plaka district, contains remarkable examples of works done by nameless artists. At times the worldly element prevails, at others the country or bucolic or the religious aspects dominate in their functions or in the decorations. The museum also has interesting displays of embroideries, metal wares, silver, wood, pottery, terracottas, traditional costumes and works by the naïf painter Theophilos Chatzimichail (1868-1934), that were inspired by everyday life and the country's glorious past. The collection of masks and costumes is extremely interesting. In olden times they were used during traditional festivals, and can still be seen in the countryside, where they are believed to bring health and prosperity.

Costumes used in Northern Greek folk festivals.

Detail of a typical embroidery from the Dodecanese.

Alexander the Great by the naïf painter Theophilos Chatzimichail.

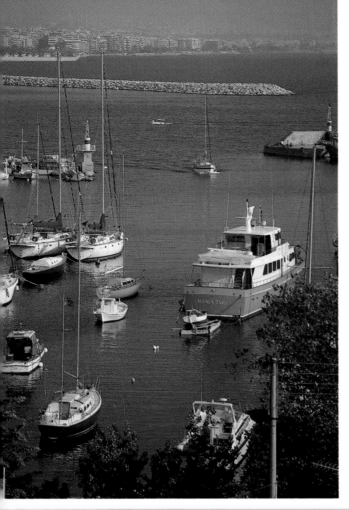

THE PIRAEUS

About 11 kilometers from Athens, overlooking the Saronic Gulf, Piraeus sits on a rocky peninsula that forms three natural harbors. Thanks to this great natural gift, Piraeus became one of the main ports in antiquity and is still today one of the most important in the Mediterranean. In the V century B.C. Themistocles fortified the city of Piraeus and the three harbors in order to protect the Athenian fleet. The fortifications were extended on land and joined the city of Piraeus with Athens by means of the Long Walls which also protected the main road that lead to the sea. Piraeus was destroyed by the Romans in 86 B.C. Much later it was known as *Porto Leone* and then, it enjoyed a great boom in the XIX century. Today it has heavy freight and passenger traffic and flourishing industry; the Piraeus is a lively city and home to many cultural events. The **Great Harbor**, known as Kantharos is used for commercial trade and coasting trade while the **Zea** and the **Small Harbor** (Microlimanos) are smaller and more picturesque, with restaurants and facilities for visitors and local residents alike.

Two views of the Small Harbour (Microlimanos).

Above: the Great Harbor (Kantharos). Below: the marina of Zea with the Great Harbor in the background.

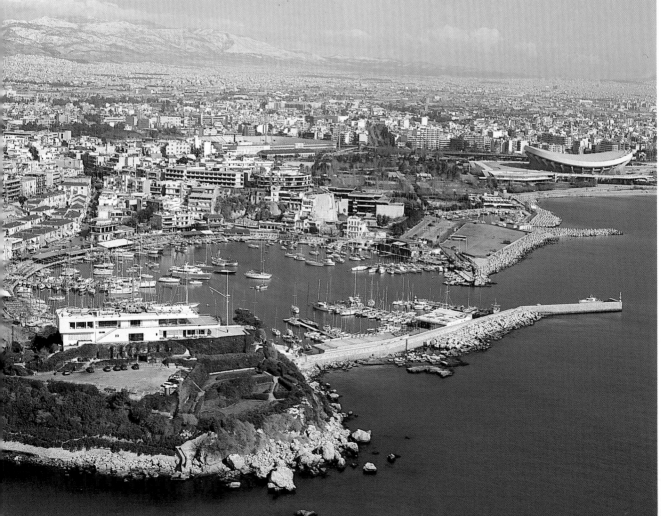

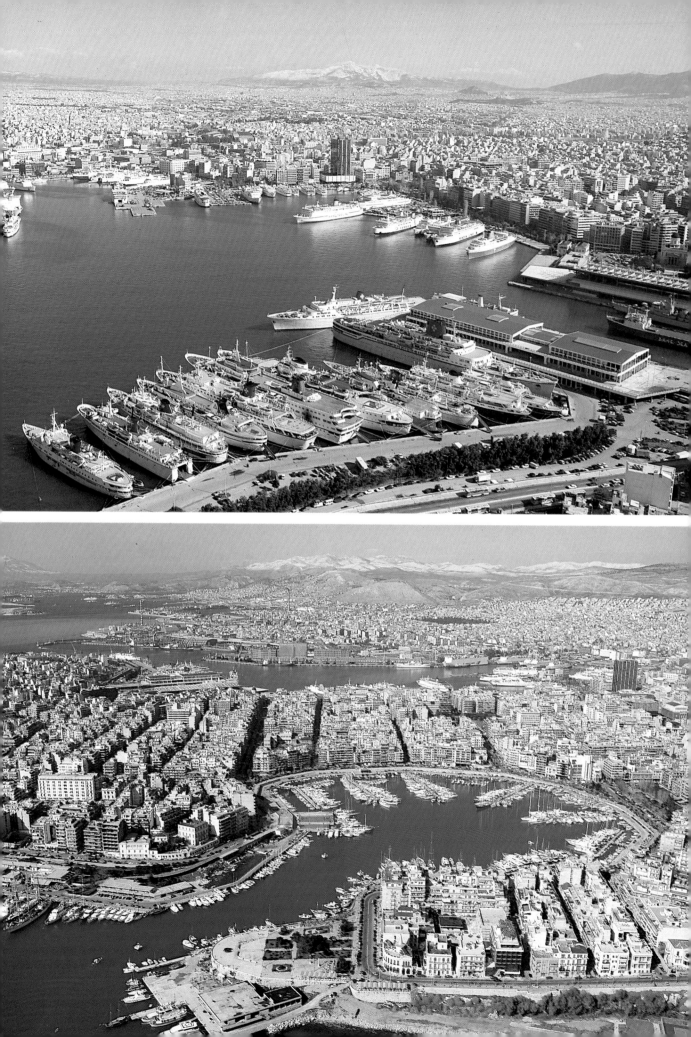

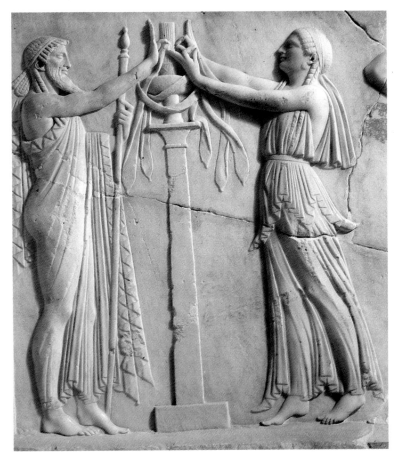

THE PIRAEUS ARCHEOLOGICAL MUSEUM

The Piraeus Archeological Museum was opened in 1981. It contains archeological finds from the Piraeus area including a fine group of objects found in 1930 aboard an ancient sunken ship that had been bound for Italy. Part of a low-relief sculpture depicting a **ceremonial scene** and **battle of Amazons**, a

Detail of a relief with a ceremonial scene.

Battle of the Amazons carved into stone.

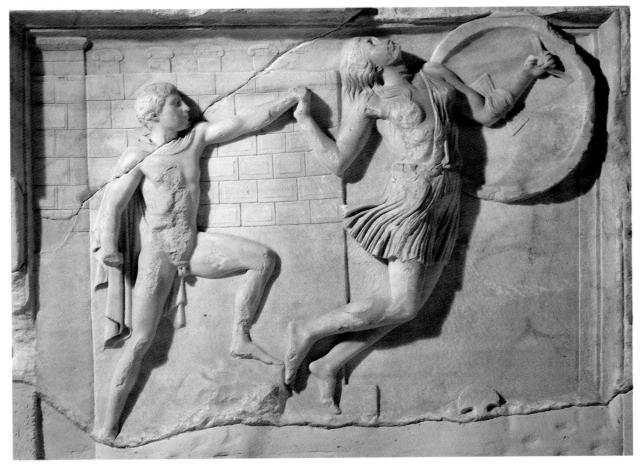

replica of a scene from shield of the statue of Athena by Phidias, in the Parthenon come from Attic workshops (middle of the II century A.D.). These were objects generally used to decorate noble homes and palaces in Rome. The bronze statues in the museum were found in 1959 and are of great esthetic and artistic interest. The **bronze statue of Apollo** (520 B.C.) is the oldest, entirely hollow cast bronze statue ever found. It is a "kouros" and portrays the god of light with an extremely thoughtful expression. In his hands he holds a bow and a libation cup. The giant **bronze statue of Athena**, the small **bronze Artemis** and the stele of Hermes date from the IV century B.C. The museum also has a fine collection of sepulchral reliefs from the V and IV centuries B.C. as well as Hellenistic and Roman statuary.

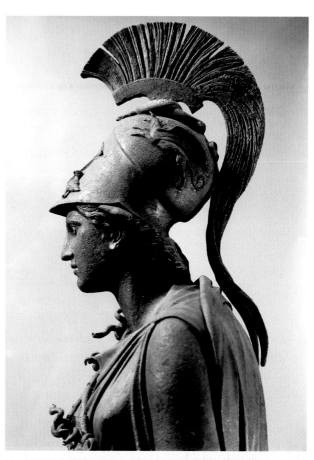

Detail of the bronze statue of Athena.

Bronze statue of Apollo.

Small bronze statue of Artemis.

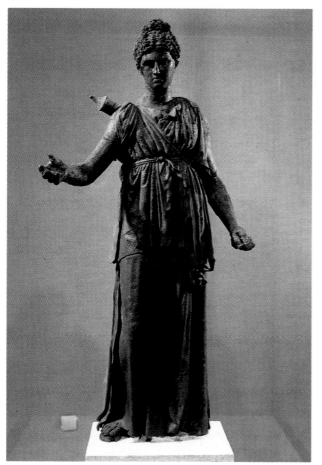

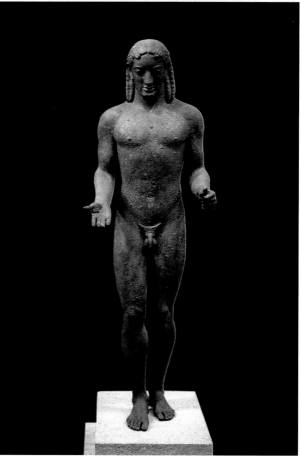

The region of Attica is particularly interesting because of the large number of towns and settlements which, along with the city of Athens, comprised the ancient Athenian city state. Both politically and culturally dependent on the capital, they developed in parallel with it. Therefore, their monuments are distinguished by excellent artistic quality and can be compared to those of Athens. Most of these ancient settlements have been identified, and the major towns and sanctuaries are described on the following pages.

ELEUSIS

About 22 kilometers from Athens, near the Gulf of Eleusis and the modern industrial city, we come to the ruins of what was the oldest city-state in ancient Attica, and the birthplace of Aeschylus, Eleusis. Along with Delphi and Delos it was one of the most important Panhellenic spiritual and religious cen-

ters; in the VII century B.C. it came under Athenian dominion. The place, with its ruins dating from the Mycenaean period to the V century A.D., offers the visitor an impressive image of an ancient sanctuary. The city flourished during the years of the mythical king Keleos(1500-1425 B.C.). It was then that, according to the Homeric hymn to Demeter, the "eleusis" (arrival) of the goddess Demeter seeking her daughter Persephone who had been kidnapped by Hades took place. The cult of the goddess of the earth and harvest included processions and religious ceremonies, the annual greater and lesser Eleusinian Mysteries. Initiates were not allowed to reveal what occurred in the Telesterion sanctuary or ceremonial room.

The ancient sanctuaries of Eleusis such as the **Telesterion**, the sanctuary of Hades, the sacred well of *Kallichoron*, the Lesser Propylaea, all appear as they did during the Roman period. The **Great Propylaea** (II century A.D.) are in the style of the Propylaea on the Acropolis.

The small local museum houses many excellent items, including sculptures related to the Eleusinian

Eleusis. Detail of the reconstruction of the Temple of Demeter. Note the Telesterion.

Eleusis. The Telesterion as it looks today, with the modern city in the background.

Eleusis. The Great Propylaea of the Sanctuary of Demeter.

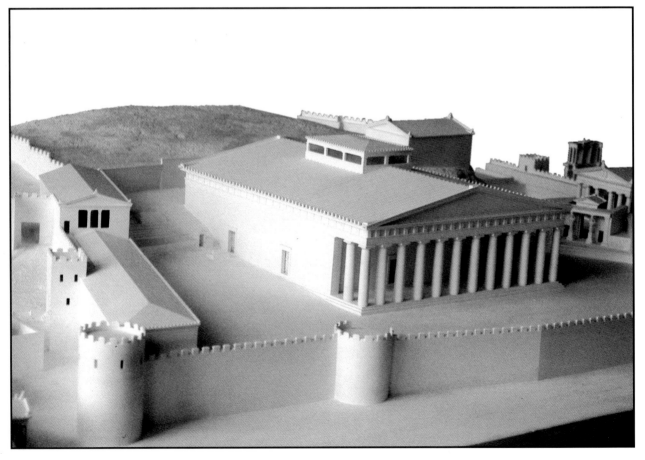

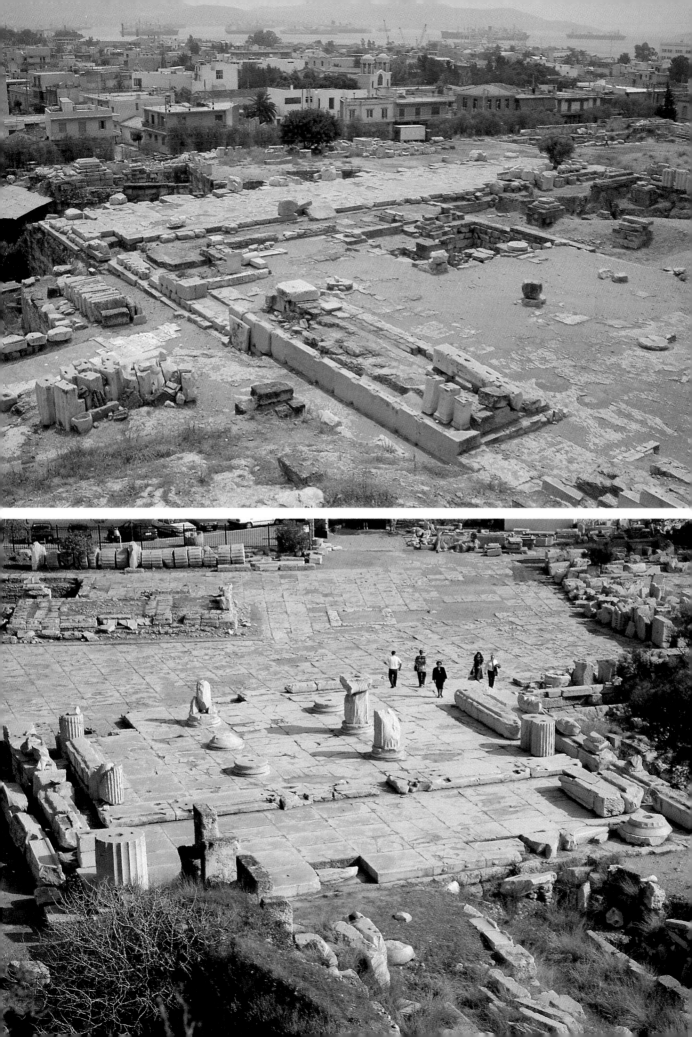

mysteries from several periods, architectural fragments and other objects including the **Protoattic amphora** which portrays Odysseus blinding Polyphemous and Perseus killing Medusa.

MARATHON

The Battle of Marathon (490 B.C.) was one of the most important contests in world's history. The famous victory of 10,000 Athenians and 1,000 men from Platea can be attributed to the military genius of the general Miltiades and his heroic troops that defeated the numerically superior Persians until then considered invincible. A messenger ran to Athens with the new of the victory. The distance he covered, that is 42 kilometers, is now run as the marathon event in the modern Olympic games. After the battle the Athenians buried their 192 dead in one grave and the few victims from Platea in a separate grave. Recent excavations have brought to light swords and spear tips which can be seen in the local archeological museum.

RAMNUNTE

This is the best-preserved town of ancient Attica, located at the northeast end of the region about 14 kilometers from Marathon. The surrounding area seems unchanged and its wild beauty is astounding. The impressive fortress on the coast, in a strategic point to guarantee the naval security of Athens has been preserved in good condition. There are traces of the ancient city, sepulchral monuments and sanctuaries, the most important of which is the **temple of Nemesis**, the goddess of revenge. Two Doric temples from the V century B.C. have been excavated, and statue of Themis by the local artist Cherestratos was found in the smaller of the two. The statue is now in the National Archeological Museum in Athens.

Eleusis. Part of the northern fronton of the Great Propylaea, the bust may be of Marcus Aurelius.

Museum of Eleusis. Detail of an amphora from the Early Attic Period.

Collective grave of the Athenian warriors who died at the Battle of Marathon.

Ramnunte. The temple of Nemesis.

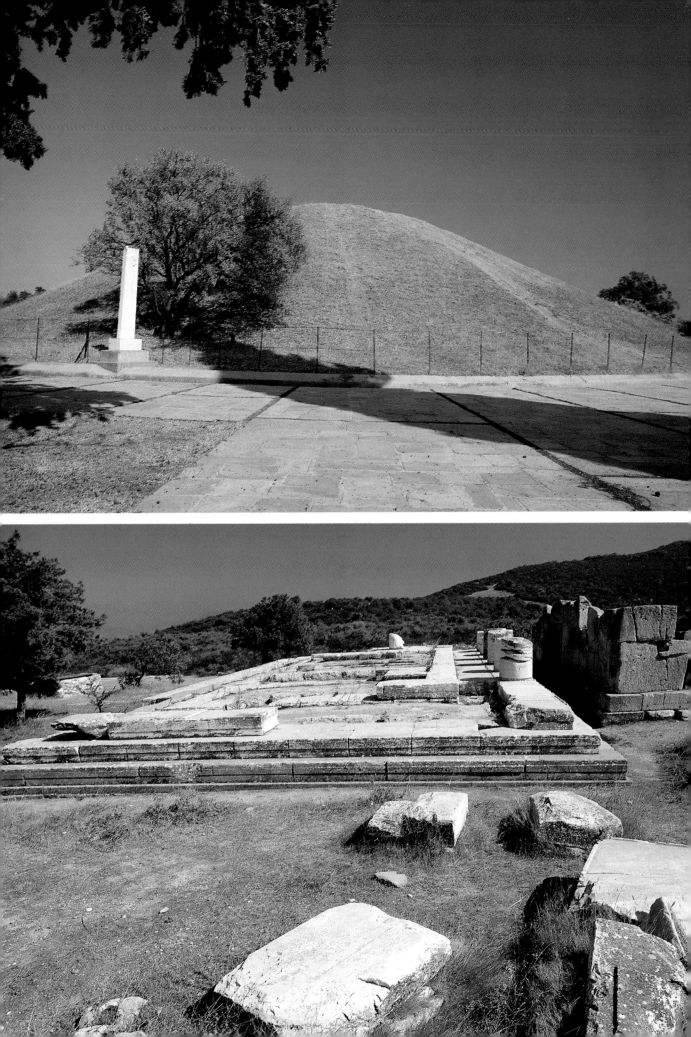

BRAURON

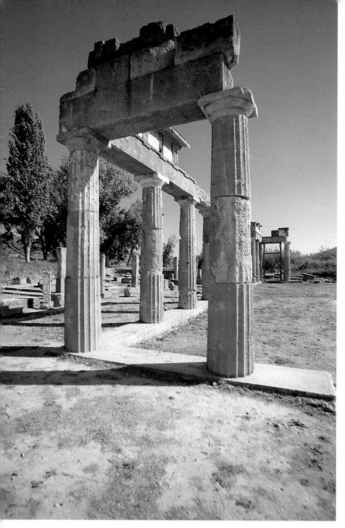

The **sanctuary of Artemis Brauronia** is located on the eastern coast of Attica, 40 kilometers from Athens. Originally Iphigeniea was worshipped here; she was the daughter Agamemnon sacrificed before the Greek fleet sailed for Troy. Later, her cult was replaced by that of Artemis, goddess of the hunt, the country and protectress of childbirth. The chitons of women who had died in childbirth or who had delivered safely were brought to the goddess's sanctuary. Young maidens dressed as bears ("arktoi") came to the stoà and participated in the rites. The *Brauronia* was a ceremony held every four years, it included a procession that began on the Acropolis in Athens, along with dances, rites, sacrifices and games. Today, at the archeological site one can see the ruins of the temple and the restored **stoa** (dating from 420 B.C.) where the niches for the maidens' beds and tables can be seen on the floor in the cellas. The local museum has a exhibit of the "bears", relief carvings, inscriptions and small objects dating mostly from the IV century B.C.

Brauron. Two views of the sanctuary of Artemis. The stoa.

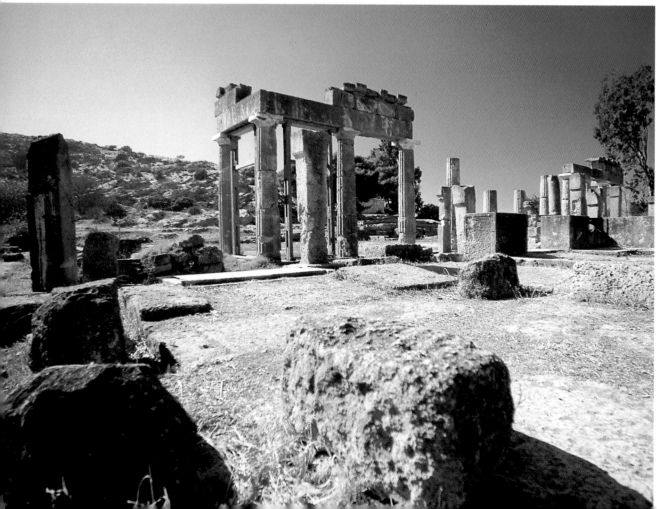

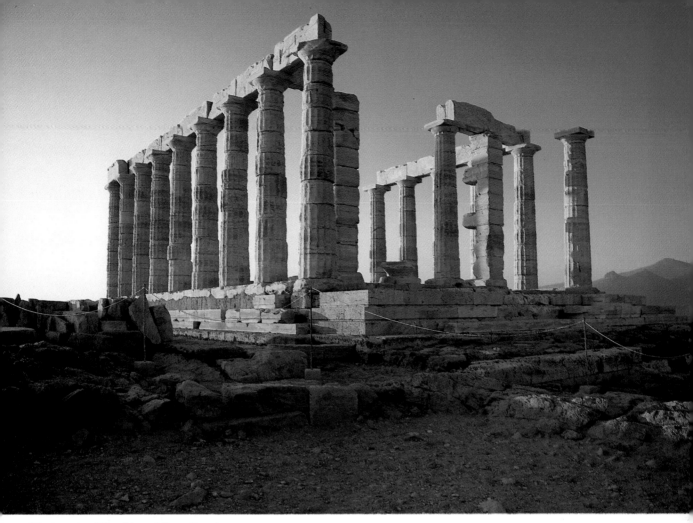

The temple of Poseidon at Cape Sounion.

CAPE SOUNION

Sounion, at the southern tip of the Attic peninsula is located about 70 kilometers from Athens. The **temple of Poseidon** rises on a rocky promontory over the sea. The god of the sea and waters, brother to Zeus, lost the competition with Athena for the possession of Attica, but he was still worshipped in several sanctuaries.

At the point where the Athenian land meets the infinity of the seas, Poseidon, protector of travellers and mariners who sail around this rough and stormy cape, was worshipped in an impressive sanctuary while a small temple was built to Athena Sounias on a lower level. The place, mentioned by Homer, was inhabited since prehistoric times, and traces of religious worship dating from the VII to VI centuries B.C. have been found. The sanctuary of Poseidon was one of the most important in Attica and was closely linked to Athens: the city officially partici-

pated in the nautical festival that was held every four years. Construction work on the first temple of Poseidon, made of poros stone, was begun in 490 B.C., and it was destroyed by the Persians shortly before the Battle of Salamis in 480 B.C. Within the context of the temple reconstruction program launched by Pericles, the Athenians who dominated the seas built a grand new temple in 444-440 B.C. In view of the strategic importance of the cape they fortified the cliff and this way guaranteed protection and supplies to their city. It was contested until the I century A.D. when even the sanctuary was abandoned, and it gradually fell into ruin. The cape, also known as Cape Colonos was visited by many Romantic travellers including Lord Byron and Chateaubriand, who were seeking the lost grandeur of antiquity. Today, after going beyond the top of the cliff, the ruins of the wall and the foundations of

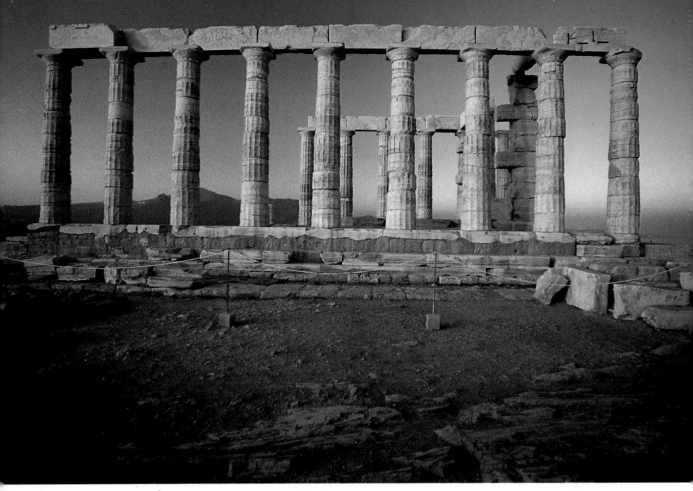

Southern side of the temple of Poseidon.

Cape Sounion and the temple of Poseidon seen from the coast.

The temple of Poseidon and sunset at Cape Sounion.

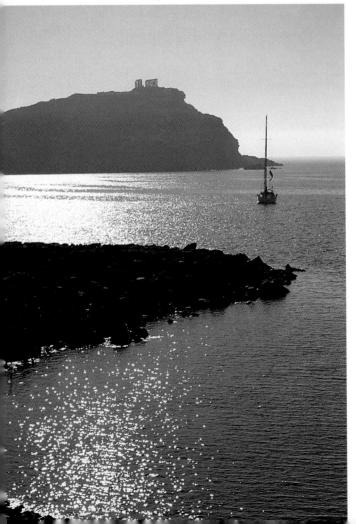

the propylaea and portico we find ourselves facing the marble temple of Poseidon with its fifteen, slim Doric columns. If we compare the architectural features and the Ionic elements of the sculptural decorations on this temple with those on other sanctuaries in Attica, it seems that it was the same unknown architect who also built the temple of Ares at Acharnes, the temple of Hephaestus and Athena (Theseum) in the Agorà in Athens and the temple of Nemesis at Ramnunte. The fascinating place with its view of the Cycladian Islands, the Saronic Gulf and the Pelopponesian Coast, with the slim lines of the columns (that are a fixed reference point for all those who sail the Aegean) and the stupendous twilight colors offer a marvelous sensation of the Attic landscape.

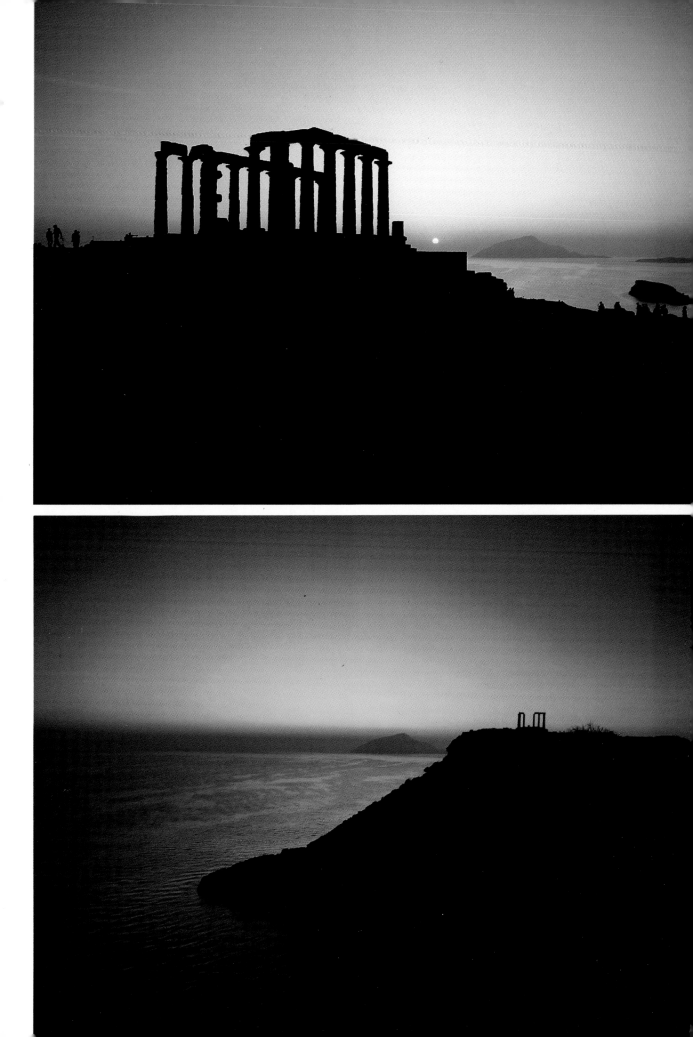

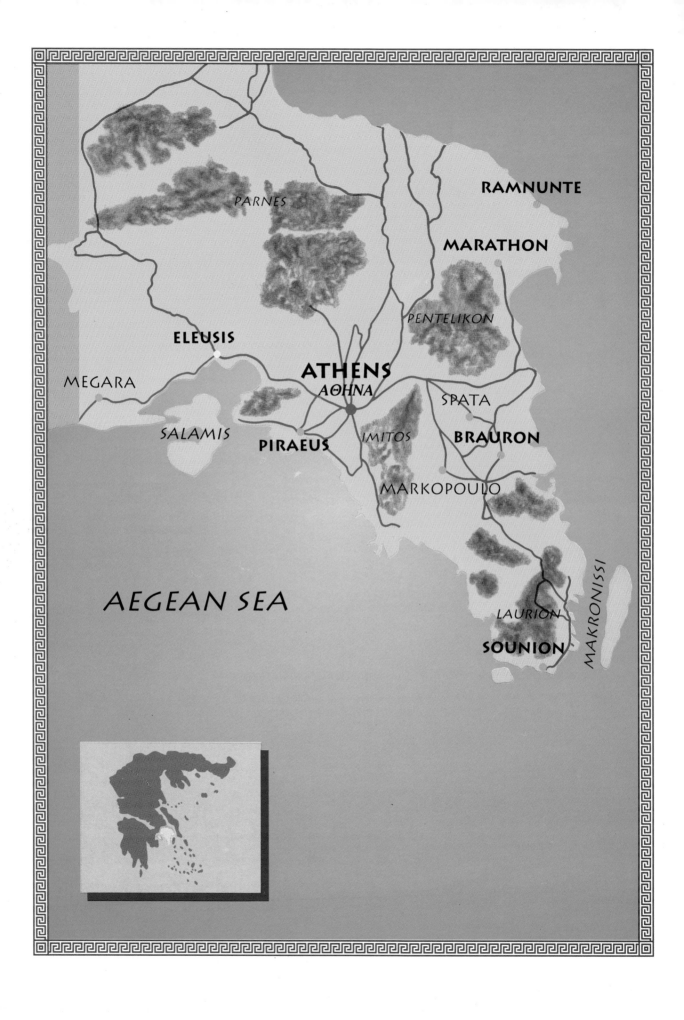

RAMNUNTE

MARATHON

PARNES

PENTELIKON

ELEUSIS

ATHENS
ΑΘΗΝΑ

MEGARA

SPATA

SALAMIS

IMITOS

BRAURON

PIRAEUS

MARKOPOULO

AEGEAN SEA

LAURION

SOUNION

MAKRONISSI